T0414303

Café Cool

Robert Schneider

Café Cool

feel-good inspiring designs

images
Publishing

For René and Mary Ann

Contents

Introduction

The COVID-19 global airborne infectious disease pandemic had a devastating impact on cafés and coffee shops. Needless to say, trying to survive as a business during social distancing, closure guidelines, and stay-at-home orders was challenging. Many cafés and coffee shops leaned on outdoor seating (weather permitting), walk-up and curbside service, bicycle delivery, and online sales. Some cafés and coffee shops even started selling staples such as flour, grains, and produce alongside coffee and prepared food items. Still—such measures were often not enough to survive with temporary closures unfortunately becoming permanent all too often.

The pandemic certainly highlighted the value of independent cafés and coffee shops as neighborhood gathering places ("third places") for people to connect, meet, create, and socialize in person rather than online.

Yet, despite the turmoil, a number of cafés and coffee shops were able to survive and new ones continued to open with quite a few owned and/or operated by women, minorities, and the LGBTQ+ community.

Consequently—*Café Cool: feel-good inspiring designs* emerged; a third book in the series, featuring thirty-nine cafés and coffee shops in twenty-six cities around the world. The curated selection shares a focus on modern contemporary designs with attention to detail, diverse materials and the unique ways they are put together, thoughtful design processes, visions and/or stories, and sophisticated splashes of color—from soft hues to bold shades.

The author was inspired in selecting the cafés and coffee shops for the book by a young ballerina performing a solo. She was confident—but not overly confident. Enthusiastic—but not over-the-top. She had a pleasing presence that engaged the audience. In short, her artistry was perfect—delightful, captivating, and special. It made you feel good—just like a well-designed space.

Importantly—a large majority of the selected cafés and coffee shops are independent and local with designs that foster a fantastic coffee experience. Designs that say welcome, enjoy, stay awhile, have a great time, and make the visitor feeling amazing after leaving and wanting to return again and again!

The attempt was to include designs that are uniquely different—in an authentic and good way allowing for emotional satisfaction to grow over time. Thus, Andytown Coffee Roasters located on the seventh floor of a skyscraper with access to an adjacent urban rooftop park is included whereas cafés and coffee shops that come across as trying too hard to be something novel but instead are actually rather gimmicky and short lived are not included.

In the end, the selected cafés and coffee shops share a story, message, or connection in a simple manner that touches the soul—feeling something remarkable that one remembers for a lifetime.

Architects / Designers

All the cafés and coffee shops selected for the book were designed by architects and/or designers except for April Coffee Roasters, which was designed by the owner in close collaboration with the House of Finn Juhl, and Hotel âme, which was designed by the founders (creative types) with the aid of professionals who produced the technical drawings and designed the custom furniture. The architectural and/or design firms that created the selected designs include well-known international firms, national and regional firms, and small boutique firms with only a couple of professionals.

Locations / Settings

Similar to the first two books in the series—the cafés and coffee shops featured in this book are located in various locations. A skyscraper with access to an adjacent urban rooftop park. A transformed railway arch. A lobby of a boutique hotel. An art foundation and center. An iconic department store. An outdoor plaza of an art and design school. An arts center next to an elevated park and trail. An inner-courtyard of a residential building. And additional locations in both historic and newly constructed buildings.

Year Completed

Thinking it would be helpful to the reader—the year each café and coffee shop was completed is included in the Project Credits (pages 250–253). The intent was not to include only the newest cafés and coffee shops but rather a curated selection of well-designed spaces to experience through the provided photos or perhaps in person—especially coming out of the global pandemic. Of the thirty-nine cafés and coffee shops featured in the book, six were completed in 2022, eleven in 2021, five in 2020, twelve in 2019, and five in 2018.

COVID-Related Closures

As previously mentioned, the global pandemic resulted in the permanent closure of many cafés and coffee shops. Many of these had wonderful and unique designs, including the following: City of Saints Coffee Roasters in New York City was completed in 2018 and featured an optimal layout for a small space, unique materials, and fresh colors—shades of sea-foam green. The award-winning design was created by Only If Architecture (New York City). Törnqvist Coffee in Hamburg designed by AENY (Hamburg) was a well-conceived minimalist design completed in 2017 that focused on coffee transparency and interaction between baristas and visitors. And Florence Coffee in Melbourne designed by CoLAB Design Studio (Melbourne)—completed in late 2019—was a delightful coffee shop located in the heart of the laneway district.

Rent Related Closures

Cafés and coffee shops often face substantial rent increases that forces them to close. For example, Joe Coffee opened an outlet on the Upper West Side of New York City in 2018 but had to close in 2022 after receiving a rent increase. Shadow Architects (New York City) designed the space that featured an oak wood bench, black tables and chairs, blackened metal shelving, and a colorful tile coffee bar—a wonderful design that was a neighborhood favorite.

Hopefully—the book serves as a pleasing presentation of modern cafés and coffee shops for lovers of coffee and good design. It may also serve as inspiration and a source of ideas for architects, designers, and those looking to open a new café or coffee shop—especially in regard to layouts, materials, colors, shapes, and positioning and placement of elements.

The reader might receive inspiration from reviewing and critiquing the designs of the projects in this book. For instance, what does the reader like about a selected café or coffee shop and what would the reader do differently, if anything, to the design? How does the design meet certain challenges such as working with a limited space, a small budget, or other functional commercial constraints? Does the design possess authenticity and integrity? Will the design endure—remain relevant over time? What separates the design from the ordinary or common? Are the elements artistically placed throughout the space? Does the design come together in a unified whole? Does the design share a relationship with nature and/or the arts, including music, dance, theater, painting, or sculpture? Does the design look unexpected and possess simplicity even though getting to the end result was a very complex and complicated process?

Regardless—it is very important, especially with the lingering effects of the pandemic, that we continue to appreciate and support quality coffee in cafés and coffee shops with feel-good inspiring designs!

"The best coffee deserves
a beautiful café"

April Coffee Roasters

Patrik Rolf, runner-up at the 2019 World Brewers Cup, got his start in coffee in his hometown of Gothenburg, Sweden. From there he worked as a roaster at a top roastery in Berlin. In 2016, he moved to Copenhagen to start April Coffee Roasters—focused solely on roasting coffee. Why the name April? Patrik explains, "The name is rooted in the importance of seasonality when it comes to coffee quality." In addition, it is also his favorite time of the year.

When COVID-19 hit, he spent his time in lockdown finalizing plans to open a storefront in order to showcase his roasted coffees. Thus—in 2020, the April Coffee Store & Showroom was opened in Østerbro—a sprawling neighborhood with cobblestone streets, colorful buildings, and Sortedam Lake.

The minimalist interior is executed with great attention to detail and successfully brings together Danish and Japanese influences.

Most noticeably, the furniture is handcrafted by Copenhagen-based designer and manufacturer House of Finn Juhl. The simple yet elegant Japan Sofa from 1957 is upholstered in a bright yellow mustard textile.

It is paired with the organically shaped Eye Table from 1948 and the elegant Table Bench with brass details designed in 1953. The Panel System functions as a backdrop behind the seating area comprised of Reading Chairs placed around the Nyhavn Dining Table. And a Pelican Chair is paired with a Pelican Table.

Patrik chose to collaborate with the House of Finn Juhl because of a correlation of values and a shared focus on uncompromising quality. Patrik adds, "House of Finn Juhl represents Copenhagen and Denmark and we wanted to recognize that—and give visitors something they can relate to."

Furthering the connection with quality—Japanese Norem were designed and hand-dyed at one of the last remaining indigo farms in Japan. The partitions are slightly translucent and divide the space in a subtle way. Japanese illustrator Ryuto Miyake hand-painted the beautiful illustrations of birds that hang in the store. And acoustic panels installed on the ceiling reduce the sound level but they also elevate the design aesthetic—helping in both ways to provide a good experience to visitors.

Patrik chose to open his roastery and then store in "dynamic, quality oriented, and innovative" Copenhagen as the city had long been a main source of inspiration. Patrik notes, "your surroundings shape you as a person and as a company." He continues, "We strive to progress the way coffee is roasted and share that coffee in a space that feels like home—welcome!"

Back In Black

Minnaërt Studio (Paris) designed this space with an attractive exterior and striking black-and-white interior—a specialty coffee shop with an in-house roastery providing a transparent experience.

The main seating area features a rather raw atmosphere with walls, posts, and even newly installed wallboard left untreated. Custom furniture is made of natural varnished pine plywood. A built-in section of drawers and shelves for retail products is flush with a sidewall—a clean and smart look. A low counter with seating faces the front windows.

Continuing toward the rear—the 26-foot-long (8-meter-long) coffee bar with customer seating consists of a steel tube structure clad with powder-coated white perforated steel sheets with its white surface top lined with polished stainless steel. The open-fronted kitchen possesses large windows outlined with polished steel frames. Above the bar and kitchen—a new glass-panel-ceiling offers abundant light and views. The coffee roasting area is located at the rear underneath a black ceiling that distinguishes it from the rest of the space.

Nicolas Piégay, founder and owner, is one of the pioneers of third wave or specialty coffee in Paris. He opened his first coffee shop in 2010, KB Caféshop located on rue des Martyrs in the 9th Arrondissement.

In 2015, he started KB Coffee Roasters and began roasting green beans at a shared roasting facility. The success of the first coffee shop led to the opening of a second coffee shop and roastery in June 2019. Back In Black is located on rue Amelot in the 11th Arrondissement near the Bastille.

Nicolas, before opening his first coffee shop, discovered a passion for coffee and honed his coffee skills during a two-year stint in Sydney, Australia. Thus the KB in KB Caféshop and KB Coffee Roasters stands for kookaburra—a common bird native to Australia that he admired while living there. And Back In Black is named after the song "Back In Black" by the Australian rock band AC/DC.

Nicolas reached out to Frank Minnaërt, a French/Australian architect and academic, to design Back In Black. The two had become friends and Nicolas knew that Frank was back in Paris after spending ten years in Sydney.

Frank mentions, "The brief was very open with a lot of freedom—which was perfect." He continues, "The great thing was to be able to talk about ideas, the concept of work, coffee and food, and not directly about visual outcome."

Nicolas notes, "The open design of the space allows starring roles for precise roasting, exceptional coffees with exact preparation, and a food menu with everything homemade—including breads and jams."

Sleek and sophisticated—the design results, summarizes Frank, "In a rather unique identity void of too much design and needless decoration."

Bonanza Coffee Roasters

Modiste Studio (Berlin) designed this striking and sophisticated café located near Gendarmenmarkt—a beautiful square in the center of the city with historic architecture and a statue of the poet Friedrich Schiller.

The architects used just three main materials—green marble for the floor and work surfaces, stainless steel, and wood. The free-form shaped coffee bar consists of green marble and polished stainless steel made by expert craftspeople in the Netherlands. The bespoke wooden shelving systems behind the bar and along a sidewall are used for retail displays and needed storage. The five wooden stools are by Danish designer Hans Wegner.

Bonanza Coffee Roasters was established by business partners Yumi Choi and Kiduk Reus in 2006—with a café in Prenzlauer Berg and a roastery in Kreuzberg. In 2016, a second café was added to the roastery site in Kreuzberg. In 2020, they opened the café on Jägerstrasse Street near Gendarmenmarkt.

Yumi Choi, a native Berliner, studied fine art and worked as an artist before discovering a passion for coffee while visiting Monmouth Coffee Roasters in London. Yumi notes, "something clicked—an awareness of the different aspects of this everyday product."

Kiduk Reus was born in Seoul, South Korea but grew up in the Netherlands. Kiduk studied fine art at Willem de Kooning Academy in Rotterdam and Rietveld Academy of Arts in Amsterdam. He initially worked, after finishing his studies, in the advertising industry and as a freelance designer in Amsterdam. However, he soon decided to change course to pursue his passion for coffee and moved to Berlin.

Both third-wave or specialty coffee pioneers, before opening their first café, Yumi and Kiduk traveled and experienced coffee in various cities, including London, Portland, Seattle, and New York. They continue to travel frequently around the world to visit cafés, roasteries, and farmer growers in coffee growing regions.

Kiduk was also one of the early pioneers in acquiring and painstakingly restoring a vintage coffee roaster with hand-made custom parts—located at its roastery in Kruezberg. As a result of this firsthand knowledge, he has been sought out by hundreds of coffee roasters throughout the world to help acquire and restore vintage roasters.

Bonanza spends more time and cost per square foot on coffee shop build-out than most shops due to use of high-quality materials and a lot of custom-made elements. This is done, Kiduk notes, "as it creates a nicer environment for customers and staff."

Kiduk comments, "design enables one to change the way people feel in a positive way when it is done well and in a negative way when it is done poorly." He concludes, "design, for me personally, is more about removing something disturbing rather than creating something."

This contemporary space with a sense of tradition is a wonderful example of modernist design language with well-chosen natural materials, artful placement of elements, and strict attention to details—clean, concise, and exact.

2.90	Espresso		Tea
3.40	Americano	4.50	Hot Chocolate
3.80	Filter		
		3.80	Iced Filter
3.20	Piccolo	4.60	Cascara Soda
3.80	Flat White		Iced Flat White
3.90	Cappuccino	4.20	Iced Cappuccino
			Frap Only in Summer

Casa Neutrale

The NEUTRALE brand was established to specialize in offering sustainable, timeless, and quality goods inspired by the natural beauty of the Mediterranean. The three founders (Nacho Aragón, Jaime Gil, and Rodrigo Fernández) decided to bring the same philosophy to the world of coffee by opening Casa Neutrale. A café that follows its "core principles of embodying meticulous craft and taste with a clear and authentic point of view."

Nacho Aragón, co-founder and co-owner, says that it had been a dream of the three founders to "open a specialty coffee shop when they were in their fifties." However, he continues, "We could not wait so we went ahead and did so in our late twenties."

Estudio DIIR (Madrid) was selected to design the café based on its previous collaboration with the brand—of designing its initial clothing store. The architects were inspired by the aesthetics and principles of the fashion brand—especially its motto "less but better."

The resulting design is thus minimalist with neutral tones representative of the Mediterranean, natural materials consisting mainly of ceramics that are contrasted with the forcefulness of the granite coffee bar top, simple lines, and natural greenery—all of which creates a calm and serene atmosphere.

Seating consists of three ceramic benches. First—a main bench runs along one side of the space accompanied by a series of furniture pieces by Ondarreta. Cabinets above the bench are covered with mirrors to visually enlarge the space. A second bench serves as a central element—guiding customers and separating the coffee bar from the seating area by way of a recessed row of natural greenery. A third bench sits under large accordion front windows that can be fully opened in good weather—merging the interior with the exterior and inviting passersby walking on the sidewalk to enter.

Iñigo Palazón del Pino, architect at Estudio DIIR, notes that the space was previously used as a fruit store that contained a concrete slab that significantly reduced its height. "We eliminated the slab that resulted in a huge amplitude to the space—a height of 11 feet (3.4 meters)," he states.

Nacho mentions, "When we first saw the site we immediately knew it was the right opportunity to create a small café in the middle of Madrid." Nacho continues, "We envisioned a monochromatic space with just two or three natural materials—and could not be happier with the end result."

The café is located on the ground floor of a residential building on Regueros Street in the Salesas neighborhood in the center of Madrid. Salesas is an emerging area with a lot of energy and commercial activity—restaurants, cafés, boutiques, and art galleries. Regueros is a quiet and narrow side street. Authentic and charming—the street has a cobblestone surface and is lined with four- and five-story residential buildings with picturesque black iron balconies.

CAFÉ Y TÉ

Espresso	1.8	Flat White	
Double Espresso	2.3	Filtro	
Cortado	2	Freddo Espresso	
Americano	2.3	Freddo Capuccino	
Con Leche	2.5 / 3	Mocca	
Capuccino	2.5 / 3	+ Leche vegetal	
Matcha Latte	2.7 / 3.2	Té	
Chai Latte	2.7 / 3.2	Cacao	

AGUA Y
REFRESCOS

San Pellegrino	3	Coca-Cola	
Aqua Panna	2.5	Smoothies	

Coutume – Fondation

The FIMINCO Fondation has transformed a former pharmaceutical industrial site in Romainville—on the outskirts of Paris—into a new cultural district supporting artists from around the globe. The unique campus-like setting consists of five separate buildings housing artists in residency, art exhibitions, galleries, and event space.

Tom Clark, co-founder and co-owner of Coutume, states, "We had the chance to be part of this new ambitious project dedicated to art and culture at the doorstep of Paris." He learned about the project through a friend who works at Parsons Paris—an art and design school that had just opened a new campus on the site with students in desperate need of good coffee. One thing led to another, and a lease was signed for space to house a new roastery, central kitchen, headquarters, and café.

The café occupies a rough space on the ground floor of the main building that has a handsome façade of brick and glass blocks. Tom notes, "The main building, a former heating plant, is very inspiring architecturally and allows us to be front and center facing the various art galleries and the art and design school."

CUT architectures (Paris), having designed the vast majority of its cafés, was selected to design the space. Tom comments, "We have a special connection with the architects who intrinsically know how to express our values and DNA through architecture."

The architects preserved the rough concrete structure with old industrial doors with hardwood ties painted a bright orange, exposed beams, and a concrete floor—while inserting a distinctive artwork (coffee bar) inspired by the art foundation site.

"The monumental coffee bar," reflect the architects, "is a luminous art installation for crafting specialty coffee." The coffee bar and the wall behind it consist of square glass blocks, that when lit, "beam a source of light as if to shine on the artists and their art."

Specific design details include powder-coated-steel furnishings, large furniture with veined plywood panels, and a carefully selected array of plants. These details, note the architects, "serve as a counterbalance to and are a welcoming visual contrast with the stripped down ambiance of the raw shell."

The architects found the existing orange paint on the wood doors an "interesting contrast with the concrete and light" so they decided to use the color for all the powder-coated elements in the space.

The architects conclude, "The rough concrete shell was a good recipient for landing a useful art piece—a space like the Palais de Tokyo contemporary art center for instance." And Tom adds, "The space makes a statement about how coffee and design can interact with and elevate each other."

Coutume – Galeries Lafayette Haussmann

Galeries Lafayette Haussmann, an iconic department store in Paris, selected Coutume after an extensive search process to open a café in a majestic space overlooking the store—all under a stunning art deco stained-glass dome that arches overhead.

Coutume retained CUT architectures (Paris), having designed many of its other cafés, to design a space that expresses its values while at the same time perfectly integrates into the architectural heritage of Galeries Lafayette Haussmann—a difficult challenge.

The architects, in meeting this challenge, created three zones within the space. The first zone consists of a majestic natural pewter counter with a molded profile that welcomes visitors and serves as a reception, preparation, and service area. This counter is leaned against a huge wooden wall panel squared by a brass-steel structure from which signage, shelves, and menu boards are suspended. The square frame is an emblematic element of the brand—as its structure and clean lines align with its approach to roasting coffee.

The second "terrace" zone with a view overlooking the store with the dome overhead contains a curved counter with high seats. According to the architects, "it unfolds like a large fluid gesture to perfectly match the contours of the existing architecture."

Finally, the third zone consists of an area of lower seating that allows for a more traditional tasting experience at a table—"resembling a more archetypical Parisian café."

Tom Clark, co-founder and co-owner of Coutume, notes that the build-out was its most efficient to date. The space was completed in just four weeks even though access was only allowed between 10pm and 6am. Despite this constraint—they finished on time in order to open on the planned opening date of March 14, 2020. However, they found out only two days prior that they would not be able to open as planned because the country was going into lockdown due to COVID-19.

Nevertheless, Tom is "delighted with how approachable the coffee bar feels, the incredible views that the café looks out onto, and how well it fits into the fabric of Galeries Lafayette Haussmann."

sucré sweets

café filtre/croissant
boisson lactée/viennoiserie
cappuccino ou latte/croissant ou pain au chocolat
café noir/viennoiserie/jus frais
espresso ou café filtre/croissant ou pain au chocolat/orange ou pamplemousse
boisson lactée/viennoiserie/jus frais
cappuccino ou latte/croissant ou pain au chocolat/orange ou pamplemousse
viennoiserie
croissant ou pain au chocolat

porridge vegan
brioche perdue Poilâne «signature»
«signature» Poilâne french toast

banana bread	5	cookie chocolat no	
carrot cake	5	cookie chocolat blan	
lemon cake	5	tigré chocolat car	
cheesecake	6	financier	
tarte de saison	6	verrine granola	

start menu 15
boisson chaude + 1 dessert (vitrine)
k + 1 dessert (pastry case)

salad & dressing 9
nfit
crème

14
9,5

BabyLone. Notre démarche est d'utiliser autant que possible
ponible à emporter.

Crooked Nose & Coffee Stories

Crooked Nose & Coffee Stories has evolved from pan-roasting coffee beans at home for friends and family in 2011, to opening its first roastery in 2013, to opening a café and roastery in 2015, to closing the café and roastery and opening the current coffee school and roastery in 2021.

Inga Pieslikaitė-Ryklienė, interior designer, designed the former café and roastery to accommodate and support its philosophy of making coffee slowly with hand brewing methods (page 56). Bright and clean, it had a natural and simple aesthetic with wooden furniture, a poured concrete floor, and white painted walls. The space was divided into two zones by a long white coffee bar. One area was a working space for baristas. The other area had tables and chairs for visitors.

The wooden chairs were designed by Italian designer Enzo Mari (1932–2020). He designed the Sedia 1 chair kit in 1974 for his Autoprogettazione project—a collection of furniture that consisted of simple and affordable materials. The kit included a set of pre-cut boards of untreated pinewood, nails, and assembly instructions—to be put together by the buyer. The buyer thus experienced a physical interaction along with a human connection through making the chair— the essence of his design philosophy that "design is only design if it communicates knowledge." And yes— the chair is very comfortable.

Inga Pieslikaitė-Ryklienė also designed the new school and roastery (pages 58–59). The space features white painted walls, black furniture, and light wooden shelves. Splashes of color are provided by a round bright blue table and two graphic artworks created by Enzo Mari in 1963—La Mela and La Pera.

The focus at the coffee school and roastery is on educational coffee events and small batch roasting. Coffee is only served during events although visitors can always buy roasted coffee beans and related products.

Emanuelis Ryklys, founder and owner, notes that his interest in coffee began as a youngster when he enjoyed the aromas while his mother made coffee with a perculator coffee pot. His childhood memory has developed into a strong knowledge of and passion for coffee. He has designed and developed his own coffee brewer called BRO. The cone brewer is made from local wood and comes with a linen filter that "softens the coffee yet becomes more solid as it lets through more oils than with a paper filter." He has written a book about coffee for the everyday coffee drinker. And he designed the cups used at the school and roastery. They are handcrafted by a local ceramicist from clay covered in actual beeswax and glazed from the inside. Emanuelis says, "We wanted cups that have a local and traditional feel but also a modern look fitting the interior."

A natural evolution—Emanuelis summarizes, "everything in our past has led to the opening of our new coffee school and roastery." He adds, "We always wanted to be motivated by what we do and from the very beginning saw coffee and design as a way to express our creativity and ideas."

Crooked Drip
150 ml — 2 eur 300 ml — 4 eur

Chemex
150 ml — 2 eur 300 ml — 4 eur 450 ml — 5,5 eur

Aero Press
200 ml — 2,2 eur

Siphon
600 ml — 9 eur

Nel Drip
200 ml — 5,5 eur

Cascara
250 ml — 1,5 eur 500 ml — 2,8 eur

Cold Brew
40 ml — 2 eur

Formative Coffee

Projects Office (London) designed this distinguished contemporary café that occupies the ground floor of a three-story modern building located between St. James and Victoria in Central London. The footprint is efficient and functional, accommodating "both rushed morning queues and relaxed afternoon conversations."

The striking coffee bar is shaped at one end to mirror the curved flatiron-shape of the building. It pops against a back wall of white tile set diagonally and a black custom steelwork with a simple menu sign. Another custom steelwork attached to the ceiling functions as a frame for carefully considered lighting. Interestingly, both steelwork forms designed by the architects were inspired "by the form of the host building and also by a diagram created at the early stage of the design process that was used to work out the flow of customers as they move through the space."

The coffee bar has a terrazzo top while the sides consist of a vinyl flooring material with a multitonal finish that complements the terrazzo—"creating a homogeneity between the mass of the counter and the floor" according to the architects.

Ian Kissick, founder and owner, is originally from Ireland. He left his hometown, however, to study Computer Science in London. After concluding his studies, he discovered specialty coffee while working in Information Technology. He became increasingly interested in coffee and started a coffee subscription business that eventually led to the formation of Formative Coffee.

Ian retained Projects Office to design a "unique and contemporary interior that would stand out in the busy café scene in London." He continues, "The end result is an environment that closely matches my initial vision—a unique space that is a joy to work in with customers telling us every day how much they like the design."

James Christian, Director and co-founder of Projects Office, nicely summarizes: "Our overall ambition was to utilize a restrained material palette and carefully considered lighting scheme to create a space which directs attention toward the coffee as the main attraction."

The design is creative and thoughtful—yet seems so effortless. The well-chosen elements and material palette makes an impact in the relatively small and unusually shaped floor area but in a rather restrained and soothing manner—"a quietly elegant space" according to the architects.

ESPRESSO
2.5

FILTER
3.0

FLAT WHITE
3.0

LATTE
3.2

ESPRESSO
2.5

FILTER
3.0

FLAT WHITE
3.0

LATTE
3.2

Grounds + RNCR Roastery

KOGAA Studio (Prague) designed this vibrant space located in an inner courtyard of a residential building. Importantly—four large skylights allow abundant natural light into the space.

The front of the space consists of a coffee bar and a seating area. The coffee bar is clad with uncoated corrugated metal sheets and has a bright orange top. The seating area contains a long custom-made wooden bench and custom-made round concrete coffee tables paired with well-chosen modern armchairs by Vitra.

The simple two-level wooden structure located in the middle of the space, behind the coffee bar, houses back-of-house activities. A bright orange steel staircase along the side leads to the second level—a working space furnished with a conference table and a comfortable sofa. The space is enclosed in a floor-to-ceiling organically shaped corrugated plastic wall lined with lush green potted plants that serve as natural air purifiers and help to maintain proper humidity levels needed for the roasting of coffee.

The back of the space is dedicated to in-house coffee production, including storage of green coffee beans, roasting of coffee beans, and packaging operations.

René Královič, founder and owner, has been involved with various hospitality projects in Czechia. René mentions that the idea behind the current space was "to expand the concept of a roastery by serving freshly roasted coffee to the public." He continues, "The space also serves as a platform for continuing education among baristas and other professionals in the coffee community."

The café and roastery is located in Karlin—a former working class and industrial neighborhood that borders the Vítava River to the north and Vítkor Hill to the south. The neighborhood was impacted by severe floods in 2002. Many of the damaged buildings have been renovated, repurposed, or replaced with modern architecture. Despite the changes, the neighborhood retains its longstanding charm with nineteenth-century plasterwork apartment buildings and 100-year-old trees.

The space was designed on a tight budget—with eighty percent of materials obtained from construction waste while the suspended lights and industrial lamps were sourced from a closed factory. Working on a small budget is challenging, but in this case, "it kept the design simple and needless of useless parts" notes architect Alexandra Georgescu.

The design was Shortlisted for Grand Prix Architektů in 2021, Longlisted in the Dezeen Awards in 2021, and Nominated for Building of the Year by ArchDaily in 2021.

Hotel âme

Hotel âme, consisting of fourteen guest rooms, a café, and concept store, is located in a beautiful historic building with a neoclassical façade dating from 1867. The hotel is within walking distance of several museums known for their collections and architecturally significant buildings, including the Kunsthal, Depot Boijmans Van Beuningen, and Het Nieuw Instituut.

Angel Cheung-Kwok and Manfung Cheung, co-founders, came across the building "with architectural soul" in 2017. Angel notes, "We had a very clear vision of what we were looking for and immediately knew it was the perfect building and location for our hotel."

Angel and Manfung oversaw every step of the four-year project from concept, branding, and interior design—to quietly opening in September 2021.

Angel and Manfung respected the history of the building by retaining as many features as possible—a sweeping staircase with cast-iron balusters, stained-glass windows, immense high ceilings, and art nouveau moldings. Manfung notes, "We wanted to preserve the original spirit of the building but bring a modern life into it—a place where old and new gracefully meet."

The interior design combines Japanese and Scandinavian aesthetics—natural materials, soft colors, simple bespoke furniture, attention to details, and a beautiful flow of sunlight.

The café and concept store are open daily to hotel guests and the public. The café, with a delightful terra-cotta coffee bar, puts coffee at the forefront with coffee and espresso made with beans from a local roaster served in ceramic cups. The concept store offers a curated selection of lifestyle items, including ceramic tableware. Both the ceramic cups used in the café and the ceramic tableware offered in the store are handcrafted by Angel.

Angel and Manfung note that the project is very personal—"reflecting our personalities, values, and way of life." They continue, "We always search for places we identify with when traveling—a certain aesthetic, skilled artisanship, or an inspiring vibe—and we strived to create such a place with our hotel, café, and store."

Angel and Manfung summarize, "We hoped to design a place with a delicately balanced atmosphere of style and tranquility where people would be inspired—and want to return."

ESPRESSO
LONG BLACK 2,5
 3

CAPPUCCINO
CORTADO 3,5
FLAT WHITE 3,5
LATTE 3,5
 4

MATCHA | CHAI LATTE 4
ICED BLACK 4
ICED LATTE 4

LOOSE LEAF TEA 3
HERB TEA 3
ICED TEA 3

STILL | SPARKLING WATER 3|5

JUICES | LEMONADES | SODAS 4

EXTRA SHOT +0.5
SOY MILK | OAT MILK

Usuwa Japanese objects for everyday use

Openhouse

Japanese objects for everyday use

Le Peloton Café

Christian Osburn and Paul Barron, two cycling enthusiasts from the United States and New Zealand respectively, started providing small group and private bike tours of Paris by launching Bike About Tours in 2006. They opened Le Peloton Café in 2015 to bring together their passion for coffee, cycling, and community. In 2022, the owners engaged CUT architectures (Paris) to remodel the space so that it would better facilitate a real community around coffee and cycling.

In cycling, the peloton is the main group or pack of riders. By riding together, the riders in the peloton reduce wind resistance to save energy and build momentum as they follow the racecourse. The owners of the café think the same is true about community—"we are better together."

CUT architectures was inspired by the passion of the cycling culture in their design of the small space. The coffee bar clad with birch plywood is centrally located—becoming the center of activity. The architects note, "Baristas and customers meet and interact joyfully around the coffee bar as they rally around their passion for cycling." Birch pegboard panels along the entire sidewall reference the spirit of the bicycle workshop—"always in motion." And also versatile: it is easy to hang and unhook the menu board, the program of bike events, water bottles, and jerseys.

Welded and yellow-powder-coated bicycle frames exist on the face of the coffee bar, the back of benches, the frames for counters and even the hooks on the ceiling at the back of the shop where regular visitors and staff suspend their bikes in "visual nods to the world of cycling." The color yellow, of course, is the color of the jersey worn by the winner of each stage of the Tour de France.

Le Peloton Café occupies a building that dates to the first half of the nineteenth century located in the Marais district in the 4th Arrondissement on Rue du Pont Louis-Philippe—a quiet street between Rue de Rivoli and the Seine River. The architects note, the funky tile floor and rough stone wall, remnants of the former space, "were kept intact and add extra soul" to the historic building.

Monmouth Coffee

Anita Le Roy founded Monmouth Coffee in 1978, but rather than expanding into a national or international chain, they have "focused on work in origin" and providing quality coffee for their wholesale customers and two iconic coffee shops in London—one in Covent Garden and the other in Borough Market.

Around 2012, Monmouth started looking for a new space to house its offices, roasting and training operations, and an anticipated shop. They eventually settled on the historic railway arches at Spa Terminus, a community of food and beverage artisans, in Bermondsey—a district just southeast of the city center and Tower Bridge.

Anita recalls that on the first visit to the site they "walked around with torches and discovered that the arches were wet with dirt floors and had no windows—only openings at both ends that were boarded up."

Anita continues that when it came time to transform the arches—they needed help: "Fortunately, Helen Berresford, Head of Sheppard Robson ID: SR and a friend of the HR Director at Monmouth Coffee, suggested she might be able to assist in transforming the arches into an inviting space for staff and customers."

Helen and her team were thus selected to turn the arches into offices, roasting and training areas, and a shop. The industrial nature of the arches has been preserved. A majority of the exposed brick surfaces have been maintained although some walls have been painted a rust red color or covered with beige acoustic panels. Ceilings have been left vaulted and clad with white corrugated steel.

The office area features simple materials and soft muted colors. Casual meeting areas are fitted with round black tables, gray chairs, wheat-colored rugs, and large pendant lamps. Private meeting rooms are enclosed with large panels of glass. Custom-made furniture includes plywood cabinets and white topped plywood desks—a nod to the industrial nature of the space. The black canopy-like structure, according to the architects "provides a sense of enclosure while preserving the scale of the vaulted arches."

The shop, selling beans and cups of coffee, is located at the front of an arch—providing an authentic and delightful coffee experience where one might hear the sound of a passenger train traveling overhead on its way to or from London Bridge Station.

Helen nicely summarizes the design. "Rather than fight the grit and the texture of the fabric of the arches, we have tried to celebrate it, adding moments of finesse and quality to lift the overall experiences of the spaces. Working closely with Anita and her team, we wanted to help create an environment for the Monmouth brand to grow, whilst maintaining its culture and commitment to creating fantastic and ethically sourced coffee."

Omotesando Koffee

Eiichi Kunitomo established Omotesando Koffee with a strong adherence to key elements of Japanese culture and tradition—including artisanship, the way of *shokunin* (craftsmanship), and *omotenashi* (hospitality).

Eiichi began serving coffee one customer at a time from an old tatami house located in the Omotesando neighborhood of Tokyo. The space was intended initially as a one-year pop-up. However, one year became two years, then three years, and then four years due to the success and cult following that the brand garnered. Sadly, the old house no longer passed earthquake-safety requirements and had to be demolished.

Russell Stradmoor joined the brand around this time as managing director—eventually becoming owner. Expansion plans focused on opening new shops within Southeast Asia. Russell says, however, that he had always envisioned opening a shop in London—being part British and having a natural affinity for the city. He explains, "We were approached with an available space that seemed like the perfect opportunity to dive in. As with most things in life, it boiled down to good timing and a dose of luck!"

Russell had previously been introduced to Alessandro Perinelli, Studio Director at Perinelli Design in Singapore, through a mutual friend. Russell and Alessandro worked together to create a shop in Singapore—perfectly capturing the ethos of the brand. Russell remarks, "It was only natural to continue our collaborative relationship to design the shop in London."

The interior features a centrally positioned coffee cube where a barista wearing a white lab coat crafts coffee for customers one at a time—just as the founder did at his original space in Omotesando. The architects note the coffee cube is "framed by intricately and precisely crafted timber screens and panels that form a layered and textured composition that visually projects the interior into the street where it is best appreciated in full scale."

The architects further note that the interior layout and flow references a traditional Japanese house. An "entry courtyard" is recreated in the foyer and cashier station by using traditional materials of charred cedar boards and granite stepping stones. The "heart" of the house utilizes light and warm tones of natural ash wood and ash wood veneer resulting in a calming and relaxing environment offering a "uniquely intimate coffee experience."

The exterior of the shop consists of a black powder-coated-steel frame and large glass panels—clean and sophisticated. Signage consists of a simple white square on a black background reflecting the square signage at the old tatami house in Omotesando.

The build-out process involved weekly briefings with local contractors as "every single detail had to be perfectly executed to make sure the space reflected the authenticity of the brand."

Alessandro summarizes, "The separation of space, the symmetry and proportion, the detail in the structures, and sincerity toward the materials convey a strong Japanese design aesthetic—apart from a contemporary minimalist style."

Russell concludes, "I'm very happy and proud of how the shop turned out and the fact that we receive so much positive feedback from our customers saying that they love the space. It is deeply humbling to hear that people travel from far and wide to visit the shop. Anywhere from Manchester, Chicago, and even Japan—right back where it all started."

Original Coffee

Original Coffee was started in 2012 by two childhood friends, Nikolaj Skovsted-Andersen and Philip Trappaud Bjorn, who sold coffee from bicycles. They opened their first coffee shop on the rooftop of an upscale department store. A second coffee shop soon followed. At this time, the two founders asked Jonas Skovsted-Overgaard, brother of Nikolaj, to join them in their adventurous journey of opening and operating coffee shops—currently fourteen throughout the city. Each location has a distinct vibe—drawn from the local environment and history of the site.

Original Coffee (Store Kongensgade) is housed in a light-filled nineteenth-century building with a classic façade, arched windows, and high ceilings.

Space Between (Copenhagen) was selected to design the space. Architect Joachim Bremer notes, "The site-specific design celebrates the contrast of old and new through the use of clean contemporary lines and hand craftsmanship in a muted color palette."

The inviting entrance is "designed for easy transition with generous space." A bespoke table formed from oak and aluminum was designed by the architects. A combined shelf, bench, and coat rack is multifunctional and efficient—"evocative of a residential space where customers can feel at home."

The coffee bar, positioned to the right of the entrance, "allows for quick takeaway while providing the space with a strong visual identity through its materiality and custom design."

The rest of the interior contains rooms with multiple seating options that cater to unique behaviors. Large communal tables in two heights for dynamic social settings. Small freestanding café tables for solitary and intimate moments. Built-in seating maximizes space and allows private contemplation or conversations.

Long doors along the length of the façade can be opened, weather permitting, to extend the café into the sunny street with views of Nyboder, a historic row house district.

The architects took into account the strategic needs of the client as well as the experience of the end-user in creating the design, resulting in "an authentic and pleasing sense of space to enjoy a coffee."

Sawerdō coffee + bakery

Scott Deely and Nord Khadum both earned master degrees in International Relations from The Graduate Institute (IHEID) in Geneva. They worked for international and humanitarian organizations before returning home and establishing various hospitality venues—"places that dared to be human." They created Sawerdō as a place to provide compelling baked goods and coffee.

BUREAU (Geneva) was selected to design the space as the founders were looking for someone with artistic convictions that would create a space with sensitivity rather than a generic front.

The architects constructed and spatialized this vision by putting everything and everyone around a staged and very material (organic shaped) table—a hosting table with a variety of configurations. The table is topped with marble, a material traditionally used in bakeries. The glass tiles on the walls also add to the feeling of an artisan workshop. The pink ceiling lights bring a touch of surrealism.

The bakery is located downstairs where a team of bakers work with local organic flour from the Moulin de la Vaux and varieties of ancient wheat from La Fermes des Terres Rouges.

The project and renovation of the space was started during COVID-19 "with the fear that putting people around a table was an endangered gathering format." However, the founders took a leap of faith that people would eventually be able to get together for coffee and baked goods and share moments of conversation once again. But everything did not go as easily as hoped for. Delivery of materials took longer than expected and prices for materials skyrocketed. In addition, problems were uncovered during demolition that required additional time and money to fix.

"BUREAU," states Scott, "helped us reimagine what a bakery can look like—and more importantly how we feel."

"The place is gorgeous," says Scott, "and the pink marble table appears to float to offer a warm yet delicate place to sit and enjoy a coffee." He continues, "The table allows for large communal gatherings but also more intimate settings thanks to its curves." He concludes, "The setting is unique and leaves a lasting impression on visitors."

In summarizing the design, architect Daniel Zamarbide references Canadian artist and photographer Jeff Wall's Lightboxes—a series of large-scale photos displayed on electric lightboxes that depict common scenes of modern life. The photographs approach human scale as if the viewer could simply walk into the scene. Daniel concludes, "Sawerdō had the chance to be in a very beautiful space that the project reveals as much as possible: an inhabited lightbox where scenes of life occur and will keep on happening."

Single Estate Coffee Roasters

Ninetynine (Amsterdam) designed this café located in an authentic 100-year-old brick building with large windows and an inviting wooden door situated on Piet Heinstraat in Zeeheldenkwartier—a charming and historic urban neighborhood within walking distance of the city center.

The focal point of the space is a slate-toned terrazzo counter that follows the line of the façade. The counter starts as a coffee bar for baristas and evolves into seating at the back of the space for guests.

The colors used throughout the space are based on those seen at coffee farms, including moss green on an accent wall along with cascara red leather seating cushions and brown leather lumbar cushions on oak benches designed by the architects.

The upstairs (mezzanine) training center is supported by cast-iron columns and features interior floor-to-ceiling windows allowing views of the baristas below. Underneath the original wooden beam ceiling of the mezzanine is a cozy seating area with a more intimate lighting scheme.

Single Estate began roasting coffee for wholesale accounts in 2009—with a focus on single origin coffees that are sourced directly from the producer. "We think coffee should be good enough to stand on its own," explains co-founder Patrick Groenewold.

Bas Burghoorn, co-founder, notes "We always felt the need to get our roasted coffee closer to the consumer to receive direct feedback—thus the desire to open our own café."

"We asked ninetynine to create a coffee bar that does not look like a coffee bar but that is really a showcase for the art of coffee making and coffee itself," says Bas. He continues, "The whole idea was to show every step of the process and invite consumers to engage and interact with the baristas."

Ulrike Lehner of ninetynine summarizes: "The interior throughout consists of a subtle play between sleek and classic with a warm color and material palette that is complemented by natural light and warm and intimate artificial lighting."

The end result is just what the two owners requested—"well-designed but still comfortable." An intimate, transparent, and uplifting interior with a focus on details that has resulted in a special space to experience and enjoy well-crafted coffee.

Typika Coffee

KOGAA Studio (Prague) created this thoughtfully designed space that evokes a sense of quiet calm. The rectangular layout consists of three distinct areas—delicately executed they flow together as a unified whole. The first area is the entrance with a custom-made organic shaped communal table with an integrated ficus tree. The second area is the counter consisting of a self-standing coffee station and a seating extension into the main space. The third area in the rear is more intimate with soft seating.

Alexandra Georgescu, partner and architect at KOGAA Studio, mentions that "the three distinct areas provide functional division between work zones for the staff as well as variety and clear communication of what is where for the customers."

The main material applied throughout the space is ordinary terra-cotta drainage pipe. Natural and earthy, yet it appears quite sophisticated. "Uniquely interesting both contextually and visually," says architect Alexandra.

The terra-cotta pipes came in long pieces with each weighing several hundred kilos. The pipes had to be cut into shorter sections using a commercial saw normally used for cutting concrete. Peter Kollar, founder of Typika Coffee, mentions "it was a very demanding process but well worth doing for the very unique result."

Thoughtful design elements adding to the unique character of the space include large windows that allow abundant natural light, powder-coated tubular steel shelving, Fameg handmade stools at the communal table, and a large round mirror that provides illumination and reflection—specifically of the nearby plants situated on floating shelves.

Peter had previously worked in the financial sector, mostly in software. However, he now enjoys operating coffee shops—two in Prague, one in Brno, and one in Warsaw. Peter states, "Doing so allows me to combine my passion for design, quality food, and well-crafted coffee along with the opportunity to work with people."

Peter approached KOGAA Studio, being familiar with their design style, "to create a modern yet timeless space with quality materials." He continues, "We also wanted the design to reflect our simple concept of offering a relatively narrow product portfolio created from high-quality ingredients."

The café is located in Nusle, a district just south of the city center. The primarily residential neighborhood possesses well-preserved older buildings and contains many small local businesses.

The design is striking and unique. "A warm space with clean lines and simple use of materials," notes Alexandra, "that embraces the idea of simple quality food and coffee served at the café."

BLACK 45
WHITE 60
HAND BREW 70
BATCH BREW 55
EXTRA SHOT 10

WAY Bakery

Studio Joanna Laajisto (Helsinki) created this poetic space—sophisticated yet relaxed. The design features a creative selection of materials and the unique way they are put together in a unified whole. Stainless steel clads the front counter. Ash is used for stools and chairs, a custom banquette, shelving, and window frames. Marble tabletops containing rich purple veins are "the perfect backdrop for the creative dishes served." Red and cream floor tiles provide texture and warmth. The bathrooms contain white tiles with red grout to reference the red floor tiles in the main area.

WAY Bakery was established by a team possessing vast experience and knowledge of the hospitality industry. Lauri Kähkoömen and Toni Kostian are restaurateurs having founded Michelin-starred Restaurant Grön. And Toni Feri operates a natural wine import business—Let Me Wine.

The café is located in a handsome 1910 building in the Kallio district, a former working-class neighborhood that is densely inhabited due to a high concentration of small studio and one-bedroom apartments. The district has a relaxed and laid-back atmosphere that is reflected in the interior designed to showcase the organic menu of food and drinks.

Joanna Laajisto states, "We created a place where the quality of the ingredients used would be in the starring role." Thus, when ordering a quality coffee or espresso one might want to have with it Köyhät Riitarit: a signature menu item consisting of sourdough French toast with vanilla-oat cream, poppy seeds, and blueberry jam.

The space previously housed a medical office that contained vinyl floors and lowered ceilings—very unsuitable for a welcoming café. The architects note, "It took a major renovation to turn the space into an authentic brick and mortar feel that complements the original architecture."

The wonderful space is an authentic representation of sensible and functional Finnish design, possessing a pleasing presence. Joanna remarks, "The interior is kept simple with some carefully chosen accents that creates an atmosphere of calm and quiet delight."

White Rabbit Surf Café

White Rabbit Surf Café, a café and paddleboard shop, is proof that "dreams do come true." Natalia Solovey, founder of SOLOVEYDESIGN, dreamed of opening a café with a unique atmosphere and minimalist design. Oleg Solovey, an entrepreneur passionate about stand-up paddleboarding, dreamed of opening a shop to rent and sell stand-up paddleboards and paddles.

Natalia and Oleg, after a short search, came across the perfect building to open their dream café and surf shop—a long neglected one-story building on the banks of the Southern Bug River. Natalia, rather than being turned off by the run-down condition of the building, focused on what it could become. She notes that her initial vision was so clear there was no need to make detailed plans or renderings—"just a simple sketch on a sheet of paper."

The married couple soon got to work renovating the space—done gradually over a year and a half and partly by themselves. Plaster was removed from walls and linoleum was removed from floors. An interior brick wall was partially removed to become an asymmetrical divider between the café and paddleboard shop. Natalia explains, "I pointed to certain sections of bricks and Oleg knocked them out with a sledgehammer."

The airy and bright interior features picturesque views of the river and a color palette of white, gray, and light wood. The central counter is made with ash wood. Custom seats with fabric cushions and leather-strapped backs line the walls. A handsome wood-burning fireplace provides warmth during the winter.

Ukrainian brands support the cozy atmosphere—tangerine armchairs from ProPro designed by Slava Balbek, a white coffee table from Staritska Maysternya, and ceramic vases from Natura Ceramica.

The white painted exterior is contrasted with black metal and plywood storm shutters. An outdoor terrace is very popular in warm weather. Oleg mentions, "There are more guests on the terrace than inside the café during the summer months."

Natalia summarizes, "The end result looks just the way we first imagined. We worked with a limited budget but ended up with a wonderful café and paddleboard shop that has become a community center featuring artists, musicians, and poets."

Needless to say, opening and operating a café or coffee shop is difficult enough during normal times let along during a full-scale war—simply unimaginable. Natalia states, "We really have a difficult time … we feel stressed and fear for our lives and for loved ones."

МЕНЮ

Чорна кава

Допіо	35
Фільтр	30/40
Ручне заварювання	50

Не кава

Апельсиновий фреш	45/60
Какао	45

Матча бар

Матча з молоком	75
+ Рослинне молоко	+15
Матча з фрешем	75
Матча з тоніком	70

Чай

Чорний, Улун, Зелений, Трав'яний	45
Журавлина, Обліпиха	40
Чай	20

Біла кава

Флет вайт	40
Капучино	40
Латте	40
+ Солона карамель	15
+ Рослинне молоко	25

Холодна кава

Колд брю	35
Колд брю з банановим молоком	65
Кава з тоніком	65

Кавові коктейлі

Кава з фрешем	65
Раф	50
Айріш	80

Допіо
Фільтр
Ручне заварювання

Не кава

Апельсиновий фреш
Какао

Матча бар

Матча з молоком
+ Рослинне молоко
Матча з фрешем
Матча з тоніком

Чай

Чорний, Улун,
Зелений, Трав'яний
Журавлина, Обліпиха
Чай

Andytown Coffee Roasters

Andytown Coffee Roasters is named after Andersontown—a suburb of Belfast, Northern Ireland, United Kingdom, nicknamed Andytown from which one of the founders is originally from. This flagship café is located on the seventh floor of a downtown financial district skyscraper adjacent to an urban park atop a transit center. The café is accessible from either the building via lobby elevators or the park via a sky-bridge—the main entrance.

PWP Landscape Architecture (Berkeley) designed the four-block-long urban rooftop park—a green oasis among skyscrapers that offers optimism and possibilities for the future. The park features 12,000 plants and 600 trees; botanical gardens and grass lawns; a play area for children; a curved walking trail; an amphitheater for events; and a dancing fountain consisting of 247 tiny geysers choreographed to correspond with the coming and going of buses on the bus deck below—designed by artist Ned Kahn.

Juniper Architecture (San Francisco) designed the café to connect with other outlets of the brand—minimal and modern with similar colors and materials. The well-positioned coffee bar is clad in Caesarstone. Europly (hardwood plywood) is used for tabletops, shelving, and bench seating. Lighting consists of recessed ceiling lights, rectangular box lights, track lighting, and round ceramic pendants custom-made by local ceramicist Sam Lee "that introduce a hand-hewn element to contrast with the minimalist design" according to architect Shane Curnyn.

Andytown was started by baristas Michael McCrory and Lauren Crabbe "to bring specialty coffee to the Outer Sunset in San Francisco." The Outer Sunset is a residential neighborhood located on the foggy west side of the city—just south of Golden Gate Park and along the Pacific Ocean.

Michael and Lauren opened their original café on Lawton Street in 2014—a small space that included a bakery and roastery. In 2017, they opened a second café on Taraval Steet as well as a third café and roastery, brought over from the original outlet, also on Taraval Street.

In January 2019, Michael and Lauren opened the downtown flagship adjacent to the rooftop park. At the time, the park was closed because of cracks in support beams—negatively impacting business. The park firally reopened in July 2019 and business became very busy. However, in March 2020, the café closed because of COVID-19 and did not reopen until August 2021. Since then, business has picked up considerably. Lauren notes, "Opening and operating the café has been insanely challenging—a real roller coaster."

Lauren explains, "It was the flexible design of the espresso bar that allowed us to weather the unpredictable customer volumes that resulted from the park closure and COVID-19 as it was designed for maximum efficiency—capable of handling large volumes of customers or operated with just one barista."

The challenge during the design process was to bring the vibe of its cafés located in the Outer Sunset to a steel-and-glass skyscraper in the central business district. Lauren notes, "We still wanted the space to feel warm and welcoming."

Michael and Lauren, in seeking the desired atmosphere, asked artist Peter Cochrane to create a work that would "bring the natural world into the space." The artist photographed the length of an ancient tree trunk uprooted during a storm—and created a 21-foot-long (6.4-meter-long) seven-panel panorama. Each panel of bark was imbued with color samples taken from the tags of Andytown's original coffee bags. The resulting

work is named after the name of the tree that was uprooted—Medusa. Peter states, "Medusa now rests for public reflection among the concrete and glass of downtown San Francisco."

Lauren summarizes, "We are so pleased to be part of the truly unique and gorgeous park—a new landmark in San Francisco." She adds, "Stopping for coffee in the middle of the day provides a moment of calm just as visiting the park provides a breath of fresh air. That is why," she continues, "we are so compatible—nothing goes together better than a cup of delicious coffee and a walk in the park."

The Coffee Movement

Bryan Overstreet initially trained and worked as a paramedic, an occupation he found rewarding and one that affirmed his passion for community and service. But, after several fulfilling years, he was "looking to switch gears."

Thus, he took a trip to visit friends who operated a coffee company in Sydney. While there, he and his friends visited coffee farms on Tanna Island in Vanuatu. Bryan immediately became enamored with the story of coffee and the people who make it possible. He began working as a barista in Sydney and soon decided that he wanted to bring the "communal vibe and celebratory nature" of the local coffee culture to San Francisco.

Back in the city, Bryan worked as a barista at a coffee shop where he met Reef Bessette, known locally for his coffee expertise. Bryan eventually shared with him his idea for an owner-operated coffee shop: "good times and better coffee." Bryan had been perfecting his "good times" approach as a barista and then at Rapt Studio where he greeted clients like friends by serving coffee and "shaking their hand instead of having them sign in on a digital tablet." And for the "better coffee" part of the plan? Bryan knew Reef was just the right person to implement it.

After three years of working and saving money, "It was time to make the jump," Bryan notes. "A random bike ride found the two of us looking at a dirty window of what looked like a garage with a 'for lease' sign on it." Before long, Bryan and Reef signed that very lease but quickly became painfully aware of the lengthy and difficult process of opening a small business. The partners ended up paying rent for two years before they were finally able to open for business. They survived the long build-out and permitting process by providing private coffee happy hours with a pushcart and sometimes from the back of a VW bus. A mobile coffee experience—hence the name—The Coffee Movement.

In that timeframe, Bryan reached out to Rapt Studio, where he had previously helmed the café, to design a coffee shop that prioritizes one-on-one interaction between baristas and customers. The designers who led the project say that "the values and personality of the owner guided every design decision." They continue, "The result is a soft backdrop that highlights an authentic and meaningful coffee experience."

Notably, the walls are finished with a soft whitewash that "turn upward gracefully to the ceiling as if forming an embrace." The coffee bar is clad in nude terra-cotta tile, bestowing "a humble and raw elegance." Simple shelves contain plants, handcrafted mugs, and packages of select coffee beans. Wooden counters feature inlays of Corten steel and sit under handcrafted alabaster sconces: "a gift to the street." Copies of the daily newspaper and a curated selection of coffee publications are available for perusal by visitors. And benches out front allow visitors to soak in the soft morning sun while enjoying their coffee.

quick
filter 3
slow
drip 4

espresso 3
piccolo 3.5
cappuccino 3.5
latte 4

add: shots, seasonal syrup
almond milk, cocoa .50

The Coffee Movement has become a complete story in which everything is authentically and meaningfully connected—including the design, baristas, customers, street-life, and neighborhood.

David Galullo, CEO and chief creative officer at Rapt Studio, notes that the project is "near and dear to my heart." He continues, "We originally hired Bryan to make coffee and greet visitors at our studio in a coffee bar setting. It quickly became a gathering place for clients and staff. Yes, the coffee was great, but also Bryan is that special kind of person who makes you feel like you are the only person on Earth. It was that interaction that we tried to highlight with the design of the coffee shop."

In summary, The Coffee Movement is an approachable and warm space built around the relationship between barista and customer. The design allows a focus on coffee and encourages conversation, interaction, and connection. A well-designed space that "is every inch an extension of its proprietor." A perfect place, Bryan notes, "to spread happiness through coffee."

An award-winning project, it received the Inside World Festival of Interiors 2021 Bars and Restaurants High Commendation.

Dayglow Coffee

Range Design & Architecture (Chicago) designed this café—tranquil, confident, joyous. The café is located in the Kimball Arts Center next to the 606 Trail—an elevated park and trail built on an old industrial rail line that borders the neighborhoods of Humboldt Park and Logan Square.

The clean and modern interior is a stunning contrast with the rough brick exterior of the two-story building. Welcoming and inviting, it draws one in with excited anticipation. The sleek concrete coffee bar is the focal point—long and low in height, open and transparent, well positioned and proportioned, with coffee equipment simply sitting on top. The monolithic bar itself becomes part of the concrete floor. A long custom perforated metal light fixture appropriately hangs over the bar. Soft peach hues and a delicate painted slat wall add to the calm atmosphere. Shelving is adequate for displaying bags of coffee—but is not excessive.

Tohm Ifergan, founder and owner, was born in Mexico City, grew up in Chicago, and as a young adult moved to Los Angeles to pursue a career in music. However, while there he developed a passion for coffee that led to the opening of two successful coffee shops.

Tohm then decided to open a third coffee shop but back in his hometown of Chicago—literally signing a lease for the space a couple of weeks before the shutdown due to the COVID-19 pandemic in March 2020. Building and opening a new coffee shop during the pandemic was "definitely stressful and by no means ideal but was absolutely well worth it." He adds, "We created a well-designed community space that brings joy and excitement and allows a deeper connection to coffee."

The coffee shop is quite unique in that it is one of the few shops in the United States that serves coffee sourced only from top international roasters—a connection to other cultures important to the founder as a member of an immigrant family that settled in Chicago.

Mason Pritchett, architect at Range Design, states: "We believe the modern design language is more appropriate in historic buildings—not to replicate the past but to have a dialogue between the two." This approach gives more meaning to both and everything about the design is balanced and comes together in a delightful unified whole, including the hand-painted signage on the façade and mural of illustrated characters referencing the 606 Trail (The 606 Commuters) in the sitting vestibule by local artist Katie Lukes.

² + MILK

⁵ HANDBREW

Equator Coffees

Helen Russell and Brooke McDonnell established Equator Coffees in 1995—roasting green coffee beans in a garage in Marin County located just across the bay from San Francisco. From the beginning, Equator has focused on quality, sustainability, and social responsibility, which has led to the opening of multiple cafés in northern California as well as co-owning and operating an award-winning coffee farm in Panama (Finca Sophia).

Equator decided it was time to bring its belief that "good coffee leads to good things" to southern California. Specifically in Culver City at Ivy Station—a mixed-use residential, office, retail, and hotel development. Helen states, "We were attracted to the site as mixed-use projects bring together diverse communities." She continues, "We wanted to create a special community hub respecting where coffee comes from and the chain of people that makes a good cup of coffee possible."

Equator initially planned on opening the café in the fall of 2020. However, COVID-19 delayed everything—including permits, materials, and construction. The café finally opened in February of 2022. Devorah Freudiger, Director of Coffee Culture, notes that "the space is more beautiful than we imagined and it is so great to be introducing our coffees to a whole new city."

Kellie Patry (Los Angeles) designed the café that embraces the history of the site—a former rail station adjacent to the Culver City Metro Station—by "subtly invoking classic train shapes and details." The design was informed by motion, steam, and inspired by futurism—the early twentieth-century Italian art movement celebrating dynamism and energy.

This "espresso futurism" suggests forward movement and features original design details, including a coffee bar with its front lacquered in raised horizontal stripes of blue, gray, and red; a commissioned mural of integrated colored custom cement tiles that mimics nearby ocean waves by Thomas Williams; Paul Henningsen PH5 red pendants by Louis Poulsen; curved white-oak tables and benches designed by Kellie; and of course the cut-aluminum red Bengal Tiger Mascot (a symbol of grace, rarity, and strength).

Visitors within the interior can look through floor-to-ceiling glass walls onto the inviting grassy courtyard as well as an outdoor seating area that includes a wonderful bespoke serpentine bench designed by Kellie Patry. She summarizes, "Images of the mountains along the equator from which coffee comes from inspired the design—espresso futurism at a metro stop in Culver City."

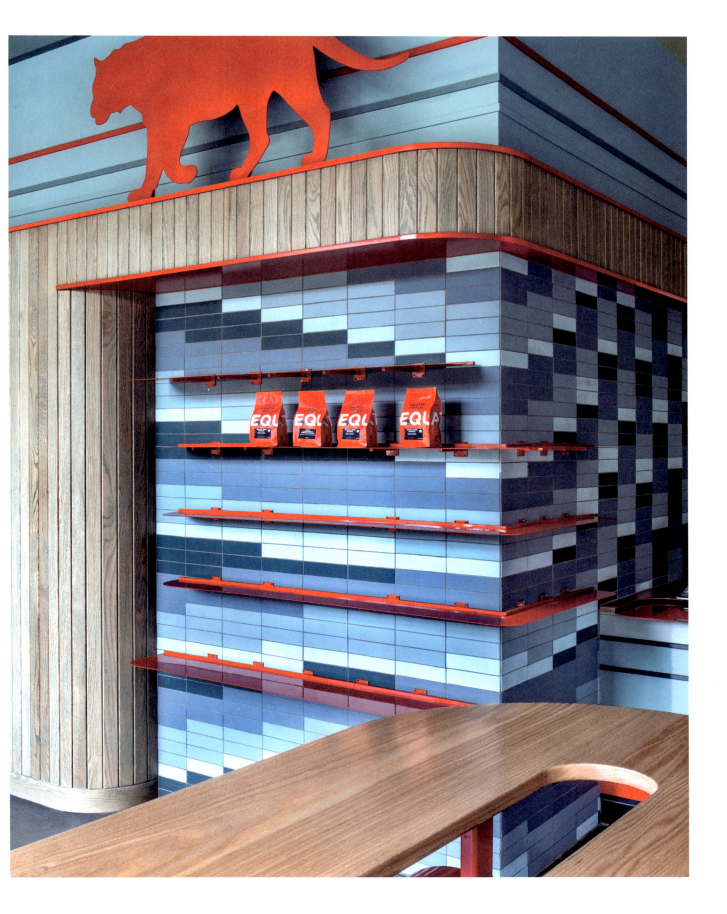

Farouche Tremblant

Founders Geneviève Côté, a lawyer, and Jonathan Casaubon, an urban planner, left their careers and life in Montréal to take up residence in the Laurentians—a mountain range in southern Québec. Geneviève and Jonathan, along with their three children, made the change to realize their dream of a full-time life in nature—"a slower and truer life."

Farouche Tremblant was created by the couple so others could share their love of nature in the heart of the boreal forest. Farouche, which loosely translates to 'wild,' is located in the municipality of Lac-Supérieur next to Mont-Tremblant National Park—approximately 85 miles (137 kilometeres) northeast of Montréal.

The beautiful mountain retreat—approximately 100 acres (4.5 hecatares) along the Rivère du Diable—combines a Nordic farm complete with barn, greenhouse, organic vegetable garden, flower fields and fallow land, four-season cabin accommodations, and a café.

Atelier L'Abri (Montréal) was selected to design the buildings to harmonize with nature. Geneviève mentions, "We were looking for a very pure and minimalist style and felt confident with the team at L'Abri." She continues, "We are very happy with the result—a place where visitors can focus their attention on the beauty of nature ... especially the beautiful and special light of the area."

The café is located in the main building with a charcoal steel roof and natural hemlock cladding—reminiscent of vernacular farm buildings. The café serves seasonal fruits and vegetables from the garden and products from other artisan producers in the region—including coffee crafted from beans roasted by a local roaster. It's a warm space where visitors can enjoy sitting in front of the fireplace and large windows or in the mezzanine lounge nestled in the roof, take in captivating views of sunsets and Mont-Tremblant, or share stories about their activities of the day. The interior is simple and open—minimalist—and its design allows focus on the natural landscape.

Activities in the surrounding area include paddle boarding on the Rivère du Diable—a gently winding river through different landscapes with sandy beaches, hiking, cross-country skiing, snowshoeing, Hok hybrid skiing, and alpine skiing available nearby. And of course—enjoying well-crafted food and coffee in the café.

There were definitely challenges along the way—rising prices for materials and compliance with local regulations. However, Geneviève and Jonathan "would definitely do it all over again." Geneviève adds, "We were dreaming of doing this for a long time—we feel we are at the right place."

Intelligentsia Coffee

Standard Architecture (Los Angeles) designed this café with a simple layout yet rich texture. The architects were influenced by Paul de Longpré—a French artist whose former estate and flower gardens once occupied the site. His gardens inspired the grid of arched vaults clad with random colored mosaic tiles—"representing abstract poppy fields." His floral paintings inspired the stenciled wall painting in the outdoor entry area.

Art deco/Old Hollywood also influenced certain elements of the interior, including dark-stained wood paneling, quilted diamond pattern stainless-steel accents, fluted mirrors used to further increase the volume of the space, and custom bronze light fixtures that up-light the vaults and illuminate the space below.

Jeffrey Allsbrook, architect at Standard Architecture, notes: "We wanted to give the space some glamour that creates a different mood than found in most coffee shops." He adds, "The glamour acknowledges the history of the site but also becomes part of the future of the famous street it is located on—Hollywood Boulevard."

Jeffrey explains that the ceiling was built with extreme precision. "We used mirrors to create the illusion of a large space at the ceiling and it works because the builder took a lot of care in putting it all together."

The 30-foot-long (9-meter-long) island coffee bar is clad in terrazzo and is complemented by a custom painted mauve espresso machine and by seating arranged, according to the architects, "like a subway car parallel to the bar."

Intelligentsia Coffee, founded in 1995, was one of the early pioneers of third wave or specialty coffee in the United States—initially in Chicago and then expanding to cities on the West Coast, East Coast, and southern United States. Lori Haughey, Vice President of Retail, notes that "all our outlets are uniquely designed to fit their respective neighborhoods—including the location in Hollywood." She was so enamored with the history of the site that during the design process she found and purchased a set of sixty old postcards featuring floral paintings by Paul de Longpré—some of which have been framed and are hanging in the café.

The design received an AIA (American Institute of Architects) Los Angeles Interior Architecture Merit Award in 2021.

Loquat Coffee

Scott Sohn and AJ Kim opened their first coffee shop, Kumquat Coffee, in 2019, in the Highland Park neighborhood of Los Angeles. A multi-roaster, Kumquat features coffee and espresso crafted from beans roasted by top roasters from around the world. AJ explains, "Kumquat helps us stay aware of how leading roasters perform. We have also felt a responsibility to maintain our multiroaster identity and not disappoint our loyal customers who have really grown to like the concept. Loquat Coffee, on the other hand, was opened in 2022 to feature coffee and espresso crafted from beans roasted on-site—allowing us to be creative and have our own voice."

Scott and AJ first met when they were training to become Certified Q-Graders—licensed professionals who grade coffee based on standards set by the Specialty Coffee Association. They both have extensive backgrounds in coffee having worked at various coffee shops for many years before going into business for themselves. However, neither one of them started out in the coffee industry. Scott actually majored in linguistics at UCLA (University of California—Los Angeles). And AJ had been planning to follow in the footsteps of many of his family members and become a dentist by studying chemistry at Boston University. However, while working as administration manager of the research laboratory at the UCLA School of Dentistry, he developed a passion for coffee and the rest is history.

Joongho Choi Studio (Seoul) was engaged to design the corner space in a one-story brick building in Cypress Park, a neighborhood just northeast of downtown Los Angeles. AJ notes he had known Joongho Choi for five years, describing him as "a true artist with innovative vision and creativity." AJ adds, "Working with an artist like Joongho was a big investment for a small business like us but we felt it was necessary in order to emphasize our creative and artisanal identity."

The architects maintained many of the original features of the interior, including exposed brick, dark woods, large windows, and a concrete floor. However, the architects applied new materials and colors to contrast with the original structure. Most notably, splashes of vivid yellow on interior walls, window trim, and outdoor tables and chairs. In stark contrast, the coffee bar and equipment is matte black as is the combination bench and receptacle bins opposite the bar.

AJ summarizes nicely: "The architects created a space with one-of-a-kind design elements where both our team and our customers are inspired to be creative—a warm street vibe from a foreign perspective."

Milky's Coffee

Fraser Greenberg, founder and owner, had long been an enthusiastic hobbyist of coffee culture as well as coffee shop design. Fraser says opening the coffee shop was a creative impulse. "There are so many channels of creativity that are possible with coffee—so the leap was made."

"We wanted the space to be warm and welcoming—a mood booster," says Fraser. "It was also important that the space exhibit our values of integrity of product and service with a strong focus on environmental and social responsibility."

Batay-Csorba Architects (Toronto) collaborated with Fraser to design this "reinvigorated expression of a café space" and for it to be vibrant and energizing in a calm manner. The tiny space features an expansive glass façade that allows abundant natural light to reach the interior—bright and energizing in the morning and calming and warming in the afternoon. The dynamic patterning that wraps the interior consists of 1,300 interlocking diamond-shaped pieces of natural wood along with marble inserts on the walls, floor, and ceiling—resulting in a sort of "caffeinated space that makes visitors feel like an essential part of the experience," notes architect Jodi Batay-Csorba.

The installation of the wood pieces and marble inserts was a challenge to get done—especially in a 100-year-old building without flat surfaces or ninety-degree angles. However, the installer worked for weeks with lasers and levels to work some magic. Fraser adds, "The precision of the patterning is satisfyingly accurate—everything lines up just right."

The remaining elements within the space complement, rather than compete with, the patterning and include a sleek white counter with a built-in and flush pastry case, white powder-coated equipment, thin metal shelves located within a small nook in a wall, and two modern custom anodized gold pendants that produce a warm glow.

"We originally designed the café for standing room only," says Fraser, "although four chairs have since been added at the front windows. The social interactions of mostly standing room only certainly fit our service and style much better than seated service ever would have."

Jodi sums the design up, "Milky's reconceives the neighborhood coffee shop as a distinctive experience that's able to define the course of the visitor's day in a few moments."

This playful yet sophisticated design received a Canadian Interiors Best of Canada Award in 2020.

Nemesis Coffee

Nemesis Coffee occupies a sculptural bright cherry-red pavilion on the public plaza of Emily Carr University of Art + Design. The pavilion and its outdoor patio furnished with tables and chairs serves as a social hub of the campus and neighborhood, an example of coffee creating community and culture.

Perkins&Will (Vancouver) designed the eye-catching structure as well as the interior with organic forms inspired by flowers found in nature. The exterior consists of five curved and overlapping 'petals' made of a hybrid timber-and-steel structure clad with bright cherry-red composite aluminum shingles. The interior complements the original architecture with 'fins' of white acoustic fabric that trace the silhouette of the building. They flow from the center of the ceiling outward toward the perimeter and downward toward the interior walls consisting of curved birch-plywood paneling.

In addition, a long stainless-steel bar meticulously placed in the middle of the space divides the seating area from the roasting and kitchen operations. Behind the bar, a continuous glass divider provides a "gradient of visual experiences" from low-iron vision glass that allows viewing of roasting operations, to one-way mirror glass that partially obscures kitchen operations, to opaque mirrors in front of the restrooms. The custom circular high table consists of a concrete base with a white-oak top with its center containing a leafy green tree—delicately executed.

Nemesis Coffee was established in 2017 with aspirations to build community and create culture through roasting and serving quality coffee. Nemesis chose to adopt the landmark structure to help establish themselves as a recognizable coffee brand in Vancouver. Co-founder Jess Reno notes, "We joined forces with Perkins&Will to create an exciting coffee house as we found that we were very much aligned regarding culture, people, and community."

The expressive building and coffee shop serves as the heart of an emerging and energetic art and design community. The architects note that "the biophilic-inspired tulip shape of the pavilion attracts an emerging community for coffee and culture as bees are attracted to flowers."

The inspiring design emphasizes illumination and reflection that unifies the exterior and interior. Architect Rufina Wu of Perkins&Will notes, "With our strongly sculptural building the inside had to reference the architecture and complement it."

The design has received the Tea/Coffee Category Winner Interior Design of Year Awards in 2021, Award of Excellence Canadian Consulting Engineer Awards in 2020, Wood Innovation Design Award Canadian Wood Council's Wood Works! BC Wood Design Awards in 2020, and Best Commercial/Retail/Office Project Urban Development Institute (UDI) in 2018.

Roseline Coffee

Roseline Coffee started as a roaster in 2012 and then opened its first café in 2019—a rather typical progression. Roseline's name is a nod to the nickname of Portland: 'The City of Roses' or 'Rose City' (reflecting its abundant rose gardens).

In Situ Architecture (Portland) designed the modern and appealing café located in a ground floor corner space of a residential building in the Goat Blocks neighborhood—aptly named because goats actually roamed the two-block area while it sat empty prior to development.

The interior contains blocks of vibrant colors—yellow, green, red, blue, and pink. The colors pop against a backdrop of black accents, a polished concrete floor, light natural wood furnishings, and an industrial vent system attached to a high concrete ceiling. Jeff Stern, architect at In Situ Architecture, notes that "the colors help to add brightness in our often overcast climate and reinforces the variety of seating zones throughout the space."

The wallpaper '100 Things' was designed and printed by Make Like Design (Portland). The wallpaper mural adds to the overall atmosphere of the interior space—playful and informal. Jeff notes, "The mural provides a strong graphic to the back wall with additional interest when viewed up close." He adds, "The black-and-white drawings offer a nice complement to the blocks of color in the space."

Paul Benschoter, founder and owner, says that "opening a café was always part of the plan." Paul wanted a space that was modern, clean, and simple, yet warm and inviting. Jeff Stern, architect at In Situ Architecture, was selected to design the café based on his modern design aesthetic.

Importantly, there was a lot of collaboration between the client and architect to provide a highly functional workspace to allow baristas to deliver the highest quality product and a great customer experience.

The space is located over an underground parking garage and has a post-tensioned concrete slab floor. Thus, "coordinating the array of plumbing and utilities that needed to penetrate the slab was incredibly challenging and required careful layout and coordination," says Jeff.

Paul summarizes, "We are committed to the neighborhood and even though opening the café took longer than expected—it was worth it in the end."

Jeff concludes, "The space is playful and fun with lots of character without being too trendy, overly self-conscious, or heavily branded." As a result, the space should remain relevant well into the future.

Thor Espresso Bar

Phaedrus Studio (Toronto/New York City) created this coffee bar located in an entrepreneurial co-working space that contrasts historic brick and wood architecture with a forward-thinking modern design— very striking and impactful. According to the architects, "The result is a highly unique and refined architecture where functional and expressive elements are interwoven."

The main spatial element consists of faceted volumes consisting of brushed, tinted, and polished stainless steel along with super matte black acrylic surfaces. The volumes reflect light in different and unique ways depending on the season and time of day. Thus they "portray a depth of nuance and complexity" that is only fully grasped by visitors from repeated visits.

The coffee bar contains a slight bend that directs the flow of visitors and adds visual interest and impact. Faz black modern side chairs by Spanish designer Ramón Esteve for Vondom complement the design geometry while a Douglas Chunk wood pedestal table by StyleGarage provides contrast. Two unassuming almost hidden doors—reflecting exceptional craftsmanship— provide access to back-of-house areas.

Tom Junek and Patrick Tu, founders and owners of Thor Espresso Bar, believe well-designed spaces elevate the experience of its visitors while at the same time reinforcing its brand. The business partners forged a collaborative relationship with the architects while working on a previous café, and so they retained them again.

The architects started with an uninviting space. In fact, it was not viable for a café due to a lattice work of mechanical ducts and pipes that greatly reduced the ceiling height. These constraints, along with service room access requirements, were viewed as insurmountable. However, all the variables were ultimately overcome with a complex network of mechanical, electrical, and functional systems that are fully integrated and concealed in the back-of-house forms.

David Grant-Rubash, partner and founder at Phaedrus Studio, humbly states, "The net result is compelling but would not have been possible without a client who respects the value of a professional architect and who equally and critically engaged in the project from the start nor without the work of exceptional craftsmen."

The project reflects its context—the corner coffee shop is accessed from the street or from the lobby of the co-working space in a historic building within a small creative hub in Toronto.

The architects created a space with a unique design language that should remain relevant over time as it does not follow current trends. David notes, "We were not influenced by what was happening at the moment." He continues, "The rawness of the existing space is complemented by and coexists with the present and perhaps the future."

This successful design received an American Institute of Architects International Honor Award for Interior Architecture in 2020, an Architecture Masterprize (Winner in Interior Design/Hospitality) in 2019, an *Interior Design* magazine Best of Year—Coffee/Tea in 2019, a Canadian Interiors Best of Canada Winner— Hospitality in 2019, and an Architizer A+Awards Finalist—Architecture+Branding in 2019.

Bicycle Thieves

Pierce Widera (Melbourne) designed this striking interior located on the ground floor of a residential building that pays homage to the highly regarded and influential 1948 Italian movie *Bicycle Thieves*.

The design is a modern interpretation of the movie and references timeless midcentury modern materials, including polished curved chrome banquette frames that reference traditional bicycle frames and soft raspberry and olive leather that reference stitched bicycle saddles.

The smart looking interior is easily viewed through floor-to-ceiling windows and features a sleek and stunning coffee bar clad with bespoke concave tiles encased in a grid of polished metal—a very modern and fresh look.

Lighting is not only aesthetically pleasing but also functional for each zone in the large space—custom linear pendants above the coffee bar, globe pendants above the large steel communal tables that bring scale to the interior, and white track lighting above the raspberry leather banquette along the perimeter.

Various seating options are well-proportioned for each zone—traditional perimeter bench seating paired with rich and warm wood tables, communal tables and stools, and high standing counters.

The architects mention that the design was one of their first larger hospitality projects but "feel quite connected to it being located in our own neighborhood." They continue, "Both the clients and ourselves are really happy with the outcome and enjoy spending time in the space."

A successful design, it is balanced and proportioned with level sightlines and well-chosen elements. Modern and minimalist, yet, notes architect Amy Pierce, "It blends effortlessly and timelessly into the historic [Italian] heritage of the neighborhood."

This award-winning design for Bicycle Thieves by the architects received the Australian Interior Design Award for Emerging Interior Design Practice in 2019.

Industry Beans

Trevor and Steven Simmons, inspired by the third-wave coffee movement, established Industry Beans in 2010—to roast quality coffee in a carefully curated environment of transparency and accessibility.

In 2013, the brothers opened their original flagship café and roastery in Fitzroy, "a hub for art, creativity, and multi-culturalism." As expected, the nine-year lease ended without the possibility of renewal, in June 2021.

March Studio (Melbourne), having an ongoing collaborative relationship with the brand, designed the new flagship café and roastery that opened just around the corner from the original in December 2021.

The one-story warehouse building with a sawtooth roof features a light gray brick exterior, large skylights, and sliding glass entrance and exit doors—very appealing and inviting.

The large interior features a welcoming coffee bar that serves as the focal point, a round bench containing a tree situated in front of the bar, a seating area consisting of two rows of booths and a long bench with tables and chairs, a roastery behind large windows in full view, a retail area offering roasted coffees for tasting and sale alongside a selection of coffee-making equipment, a training room, and offices.

The interior design is meant to reflect the journey of the brand over the past ten years and celebrate its return to the neighborhood. Thus, the interior is lighter and brighter than its predecessor with white, cream, and gray colors; abundant natural light; recycled Australian red ironbark tables; sleek booths; and abundant natural green plants.

"The long vertical rectangular pendants were suspended from the existing sawtooth roof," notes architect Rodney Eggleston, "as an economic way of introducing light at a low level without the need for further structural work."

The 'latticed' steel sections and artificial lighting successfully "mitigate the large expansive volume of the warehouse building and provide a more intimate space for the human scale," notes architect Rodney Eggleston.

The project was built with several sustainable and ethical initiatives, including using salvaged timber, repurposing all the bricks removed to provide views between the café and roastery, a work experience program offering hands-on experience for women entering the industry, and the repurposing of construction material waste into a pop-up takeaway store during COVID-19.

Trevor Simmons summarizes, "We wanted to create a welcoming environment with a coffee bar that invites interaction between baristas and visitors along with a roastery in full view."

Overall, this is a special design with a pleasing presence that "offers a new hospitality experience and a unique perspective on coffee production." Upon leaving the space, one might notice the small but stylish exit sign by the door and realize that everything about the design, including the smallest of details, has been so wonderfully executed. Thus prompting the person to return again and again!

Upstanding Citizens

We Are Humble (Melbourne) designed this modern coffee shop with a rather retro luxury look and feel. The coffee shop is built around the quick coffee, "that transitory moment that happens on your way into the office, when you come back from a meeting, or when you are between appointments." Thus, having conceived the space as one of transition, the architects were inspired by visualizing train station waiting rooms from a bygone era of luxury train travel.

The small footprint is located at the rear on the ground floor of an office building that is elevated above street level. The elevation posed a significant challenge to the architects as to how to engage the space with the street. This challenge was met by placing a large, illuminated sign in the center of the space designed to be seen from the street. The architects note, "The sign tells those on the street outside in no uncertain terms what is on offer inside—COFFEE."

Tasmanian stringybark is used consistently throughout the space including on the coffee bar, walls, benches, and joinery. The elegant and inviting coffee bar is tucked against one side of the space, "imagined as a kiosk one might encounter on a train platform." The paneling on the walls is contrasted with strong white vertical poles that emphasize the dramatic height of the space.

Upstanding Citizens reached out to the architects based on a recommendation by one of its past clients that emphasized their ability to design different styles of projects to suit a particular space. In this case, a small footprint with a high ceiling. The architects note, "We wanted to make the most of the height and at the same time use horizontal elements to create a sense of spaciousness."

The architects mention that "the final design is not nuanced or abstract but is rather unambiguous." They continue, "The space tells one what it is about from the get-go—come get your coffee."

The architects summarize, "We think the true success of the project is the overall feeling of comfort and calm the space imbues." They continue, "The detailing in the timber strapping was beautifully executed by the builders with the cleanness and simplicity of the design brought to life allowing the background elements to become the star of the space."

Drop Coffee

Roar Studio (Dubai) designed this minimalist space with a central coffee bar area delicately framed by a pale wooden structure—a theatrical stage for the making of coffee that is well accentuated by strategically placed LED lights. The bar itself is clad in pale oak with a stainless-steel top chosen for both practical and aesthetic reasons. It sits on top of a lit glass block base "giving the impression it is floating above the floor."

Various seating options include an orange La Cividina sofa, a sleek banquette with a concrete block base, freestanding tables and chairs, and a stand-up counter with clamp-on orange circular trays providing a sophisticated hint of color.

The artistic wall mosaic of broken ceramic tiles forms an abstract pattern similar to the terrazzo-like porcelain tile floor. "It forms an intriguing counterpoint," notes architect Pallavi Dean, "as if the broken chips were used in the flooring."

The color palette, muted with splashes of color, was appropriately guided by the roasting process of coffee beans.

Ghanim Salah Al Qassim and Mamood Al Khamis established Drop Coffee to deliver a unique coffee experience with a team of world-class baristas from multiple countries around the world who speak over a dozen languages.

The owners chose for their second outlet a space in the upscale Dar Al Wasl Mall. They sought a minimal design aesthetic that would accommodate the flow of customers coming from two separate entrances— one connected to the outdoors and the other to the indoors of the mall. Roar Studio accomplished this by creating a design that addresses both access points by placing the grab-and-go coffee bar in a central location.

Striking but restrained, "the interior design is consistent throughout with all the different elements streamlined and responding to one another" notes Pallavi Dean (founder and creative director of Roar Studio).

Retail
Retail

⌁ EST@2016
◎ @DROPDUBAI
SPANISH LATTE
COLOMBIA
ETHIOPIA
PICCOLO
DROPLESS
AEROPRESS
COLD BREW

EST@2016

@DROPDUBAI

SPANISH LATTE

COLOMBIA

ETHIOPIA

PICCOLO

DROPLESS

AEROPRESS

COLD BREW

Fifteen Steps Workshop Coffee

Fifteen Steps Workshop Coffee occupies the corner ground floor of a mixed-use building located in the commercially bustling XinYi District in Taipei.

Kurt Chao, founder and head barista, had been looking to relocate his original coffee shop "in a novel way to further boost his brand within the city."

Rather than opting for a traditional open-floor plan—he wanted his new shop to have a quality quick service coffee bar, an on-site roastery, and a multipurpose room for guests and private events.

Phoebe Says Wow Architects (Taipei) thus divided the space into three distinct areas. First—a semi-open street pocket service bar where guests can order coffee and enjoy it at the standing counter or while sitting outdoors on the front steps and landing area adjacent to the sidewalk. In addition, the architects took advantage of the corner location to create a takeaway window around the corner on a pedestrian-friendly side alley.

Second—a multipurpose room, secluded yet light filled and dotted with potted plants, allowing guests to enjoy coffee at a slow pace, and is also used for private events, including coffee tastings and lectures.

And third—a roastery located at the back of the space. Kurt Chao mentions that he has been "roasting coffee for over twenty years and has roasted coffee for his coffee shop since day one."

Polycarbonate panels framed in bright yellow steel distinguish the three different areas. Semitransparent, the panels diffuse light and reveal silhouettes of people and activity inside—"creating a sense of allure for passersby."

Kurt Chao explains, "The yellow color represents the endless momentum of the brand" and results in a rather playful graphic quality.

The architects faced several issues during the construction process, including a temporary shutdown of the factory manufacturing the metal frames and other delays due to COVID-19 pandemic policies. Fortunately, the architects worked through the issues to finish the build-out only slightly behind schedule. The architects note, "We were very grateful that the client was flexible regarding the project deadline given the difficulties faced during construction."

Phoebe Wen, co-founder and Creative Director of the architectural firm, enjoys visiting the shop for an "artisan coffee in a community welcoming atmosphere." She continues, "The recessed serving area as a street pocket along with the raised sidewalk platform welcome the breezes from nearby hills—engaging coffee lovers with the neighborhood."

The architects summarize, "We wanted our design to bring vibes and styles to the neighborhood." The minimal yet vibrant design using color, translucency, and geometry, allows the coffee shop to become the interface between coffee and local culture.

Phoebe Says Wow Architects received the *Interior Design* magazine best design award in 2022 in the Coffee/Tea Category for its design of Fifteen Steps Workshop Coffee.

Nagasawa Coffee

Kazuhiro Nagasawa, founder and owner, was introduced to coffee over twenty years ago. He opened his own coffee shop about fifteen years ago because he "loves coffee so much." The time came, however, when he needed to move to a larger space that could fit a newly acquired 1960s vintage roaster.

Kazuhiro met architect Atsuo Arii through a graphic designer who was working on a new logo for Nagasawa Coffee. Kazuhiro shared his vision for a new space with the architect—"a workshop space rather than a packed café"—and they decided to proceed.

The end result is a new café and roastery that evokes feelings of harmony and serenity. The main spatial element is the long and wide terrazzo table, designed by the architects as a "piece of urban furniture." The table serves as a place to sit and as an active working table for displaying unroasted, roasted, and packaged beans—showcasing the sequence of the coffee bean roasting process. The low height of the table lowers the eye level in relation to the ceiling, "making it seem like a stage." Its parallel positioning with the coffee bar is appropriate as it creates continuity of space with the entrance.

The architects succeeded in creating an open workshop—a café and roastery with clean and unobstructed sightlines that delights the senses and that plays "a significant role in the urban cultural scene in the city."

Open and transparent, there is no barrier between the vintage roaster and the rest of the café with its modern interior elements. The banquette seating along the front window is smartly conceived and implemented versus the typical high counter and stools often found at front windows. The chairs accompanying the terrazzo table were salvaged from the previous café. However, the legs were shortened so the newly painted chairs would fit the low table.

The louver wood ceiling was designed as an element to conceal mechanical equipment but it also gives a sense of spaciousness to the original ceiling—just 9 feet (2.8 meters) in height. The ceiling is made with Japanese cedar, commonly used for ceiling framing and other structural purposes in the construction industry in Japan.

Kazuhiro notes, "The roasting machine is close to the visitors so that they can feel close to the coffee and drink slowly." He also notes that he "likes that the coffee shop feels spacious—not oppressive—even though the ceiling is not very high."

PONT Coffee

PONT Coffee opened its second café and roastery in Mullae-dong—one of the oldest industrial areas in the city of Seoul—with many of the former factory buildings being turned into artist workshops and galleries. The café occupies an old red-brick building that formerly housed five separate ironwork factories.

Studio stof (Seoul) was selected to design the space for its adaptive reuse while maintaining all the things that make the building so distinct—a wonderful combination of old and new.

The original rough and raw ceiling was partially exposed to create added height and depth to the space and to allow sunlight to enter through various types of windows.

The orange-toned interior, consisting of various finishes, including plywood, terra-cotta tiles, and plaster walls, aligns with the image of the brand of providing bright and warm service.

The curved plywood coffee bar is painted different flashes of burnt orange and is located just within the main entrance, eye-catching in a sophisticated manner.

The placement of the curved furniture in various ways throughout the space, note the architects, "induces the movement of gaze that gives connectivity to the space that used to be five independent places."

The architects artfully connected the characteristics and history of the region and building with the newly created interior, "maintaining an overall balance." This was accomplished with materials, details, and forms commonly found in the surrounding area reflected in the design, including discolored wood and metal and the irregular patterns on the floor.

Seongjae Park, lead architect on the project, summarizes: "We felt disharmony from the factories still remaining in the area and the newly built buildings and created a design to hopefully fill the gap between the two."

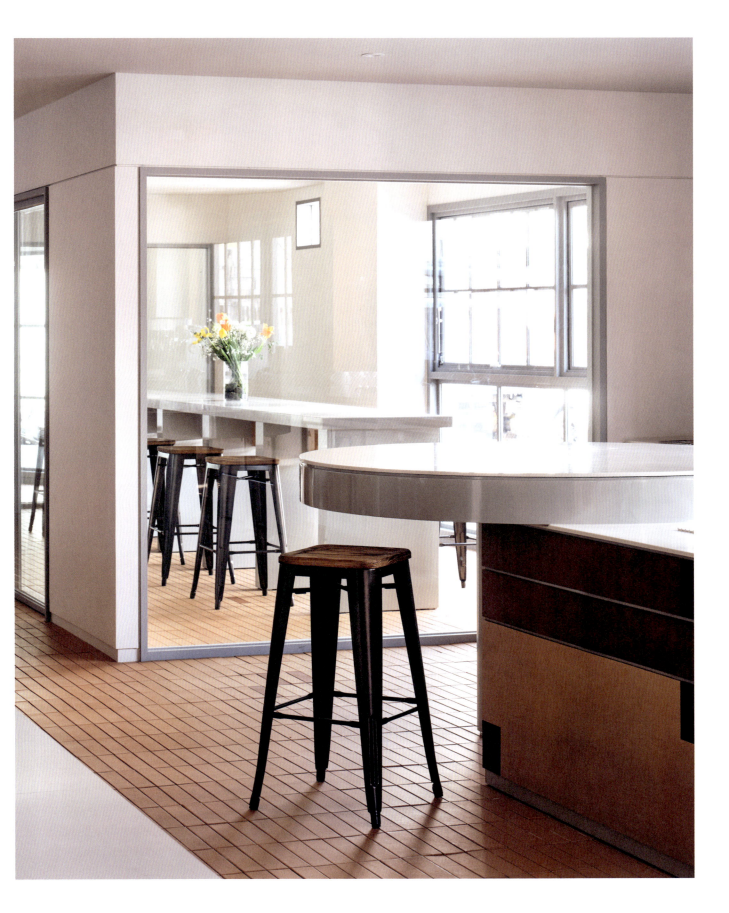

Shanghai, China

The Second Coffee Brewers

The Second Coffee Brewers, named as a call to embrace every second while enjoying coffee, engaged STUDIO DOHO (Shanghai) to create a café with an inviting and relaxing atmosphere that highlights the product—coffee!

The architects thus set out to design a simple yet strong space that would have the desired atmosphere but also enable baristas to work efficiently and provide a true specialty coffee experience for visitors.

The café occupies the corner space of a building with a bright white façade with orange and wood accents that makes a prominent presence on the street. One side of the building shows the coffee counter strategically placed next to the window to encourage interaction with the outdoors and allow passersby to view and appreciate the art of making coffee. A takeaway window makes it easy for customers to quickly order coffee to go—ideal as the popularity of coffee delivery has been increasing in China.

The other side of the building contains a fully operable façade that can swing open, providing an exciting and dynamic seating space where visitors can engage with the bustling activity taking place in the adjacent public square. The architects note, "The movable façade is definitely the highlight of the project and a unique opportunity to genuinely blend the interior and exterior."

The interior features a minimal color and material palette of "white and wood that evokes simplicity while freshness is added by mint green and orange tones." The tile design on the wall of the indoor booth is inspired by hourglasses and clocks. Visitors, while enjoying coffee, can slow down the pace of life and enjoy a moment of escape. The terrazzo design on the floor references the natural stones outside, allowing visitors in the room to enjoy the comfortable feeling of having coffee outdoors. Minimal graphics and menus help keep the space calm and neutral.

The specifically crafted design elements—movable façade, shelves, booth seating, and custom door handles—separate the space from the common or ordinary and elevate the coffee experience for visitors.

Architects Xin Dogterom and Jason Holland conclude, "We believe design is storytelling and in this case the story told is one of passion for craft—coffee and design." They continue, "It was rewarding to see everything come together with the client and design team perfectly aligned that resulted in an exciting space to enjoy coffee."

THE SECOND
COFFEE BREWERS

BLACK
WHITE
FILTER
MORE

SSAP Coffee

SSAP Coffee occupies the ground floor of an older red-brick building in Nam-gu (Southern District) in Ulsan, a coastal city northeast of Busan. The café is located near Ulsan Grand Park—the largest urban park in South Korea. Ulsan Museum, a history museum that details life from prehistoric times to the present in Korea, is located adjacent to the park. The park opened in 2006 while the museum opened in 2011.

SSAP Coffee selected design by 83 (Busan) to design a "vintage and hip space." The designers met the challenge by maintaining the history of the building while infusing it with modern elements.

The space was stripped back to reveal its original structural elements which were largely left intact: rough concrete walls, worn concrete floors, utility pipes, and metal framed windows.

The main entrance door and a door for ventilation are made of zinc steel sheets. The folding front windows are covered with birch plywood (facing outside when closed) and metal (facing inside when closed).

Design by 83 and Furniture Tt (Thanks to) designed the furniture that has been artistically placed throughout the interior, resulting in "relaxed arrangements offering visual comfort."

The modern furniture pieces possess minimal form yet are quite dramatic. The chairs with cushions and bench with cushions are made from aluminum. The accompanying tables have Melamine resin tops and stainless-steel bases. The chairs without cushions have aluminum frames with oak veneer seats and backs.

Futuristic acrylic lighting, note the designers, "forms an organic relationship with the whole space by bringing the color of the exterior bricks inside."

The design of the café hopes to invite visitors pursuing a unique experience. But at the same time, the design attempts to attract locals from the neighborhood seeking comfort and familiarity through the use of traditional materials such as concrete, steel, and wood.

The combination of traditional materials with the addition of custom modern furniture and red accents and lighting has resulted in a cozy café. A thoughtful design that the designers hope will "last and continue to deepen."

Chan-eon Park, Creative Director at design by 83, nicely summarizes: "We designed the space to have a unique atmosphere by unifying the relationship between the interior and the exterior—in terms of color, form, and texture."

About the Author

Robert Schneider currently pursues his lifelong interest in art and design while overseeing the restoration of his contemporary house set among trees—appropriately named Tree House. He lives and studies art, architecture, design, and photography in Minneapolis, Minnesota, United States.

Café Cool: feel-good inspiring designs is Schneider's third book in his design series on coffee shops and cafés, bringing together a selection of well-crafted interior spaces by those with both a strong sense of good design aesthetics and a refined appreciation of the art of a good coffee experience.

Schneider's first title was the very successful *Coffee Culture: hot coffee + cool spaces*, and presented coffee shop designs from across the United States. For his much-anticipated follow-up, *Café Culture: for lovers of coffee and good design*, Schneider expanded on the theme by showcasing a wonderful new collection of designs, this time from around the globe, including from Australia and New Zealand, Europe, China, South Korea and Japan, Britain, and North America.

Project Credits

Andytown Coffee Roasters (pp. 126–131)

andytownsf.com

Design: Juniper Architecture (juniperarchitecture.com)

Photography: Juniper Architecture; Tim Griffith; Marion Brenner

Year completed: 2019

Area: 1,593 square feet (148 square meters)

April Coffee Roasters (pp. 18–23)

aprilcoffeeroasters.com

Design: In-house with House of Finn Juhl

Photography: andershusa.com; April Coffee Roasters

Year completed: 2020

Area: 807 square feet (75 square meters)

Back In Black (pp. 24–29)

backinblackcoffee.com

Design: Minnaërt Studio (frankminnaërt.com)

Photography: LMNB Studio

Year completed: 2019

Area: 1,722 square feet (160 square meters)

Bicycle Thieves (pp. 190–195)

bicyclethieves.com.au

Design: Pierce Widera (piercewidera.com.au)

Photography: Derek Swalwell

Year completed: 2018

Area: 2,368 square feet (220 square meters)

Bonanza Coffee Roasters (pp. 30–35)

bonanzacoffee.de

Design: Modiste Studio (modistestudio.com)

Photography: Robert Rieger

Year completed: 2020

Area: 506 square feet (47 square meters)

Casa Neutrale (pp. 36–39)

casaneutrale.com

Design: Estudio DIIR (estudiodiir.com)

Photography: David Zarzoso

Year completed: 2021

Area: 700 square feet (65 square meters)

The Coffee Movement (pp. 132–137)

thecoffeemovement.com

Design: Rapt Studio (raptstudio.com)

Photography: Suzanna Scott Photography

Year completed: 2019

Area: 301 square feet (28 square meters)

Coutume – Fondation (pp. 40–45)

coutumecafe.com

Design: CUT architectures (cut-architectures.com)

Photography: David Foessel

Year completed: 2022

Area: 753 square feet (70 square meters)

Coutume – Galeries Lafayette Haussmann (pp. 46–53)

coutumecafe.com

Design: CUT architectures (cut-architectures.com)

Photography: David Foessel

Year completed: 2020

Area: 872 square feet (81 square meters)

Crooked Nose & Coffee Stories (pp. 54–59)

crooked-nose.com

Design: Inga Pieslikaitė-Rylienė

Photography: Darius Petrulaitis; Šarūnė Zurba

Year completed: 2021

Area: 1,076 square feet (100 square meters)

Dayglow Coffee (pp. 138–143)

dayglow.coffee

Design: Range Design & Architecture (rangedesign.com)

Photography: James John Jetel; Jim Vondruska

Year completed: 2021

Area: 495 square feet (46 square meters)

Drop Coffee (pp. 208–213)

dropdubai.ae

Design: Roar Studio (designbyroar.com)

Photography: Oculis Project

Year completed: 2021

Area: 1,399 square feet (130 square meters)

Equator Coffees (pp. 144–147)

equatorcoffees.com

Design: Kellie Patry Design (kelliepatry.com)

Photography: Fred Licht

Year completed: 2022

Area: 1,399 square feet (130 square meters)

Farouche Tremblant (pp. 148–153)

farouche.ca

Design: Atelier L'Abri (labri.ca)

Photography: Raphaël Thibodeau

Year completed: 2022

Area: 4,994 square feet (464 square meters)

Fifteen Steps Workshop Coffee (pp. 214–221)

fswcoffee.com

Design: Phoebe Says Wow Architects (phoebesayswow.com)

Photography: Hey!Cheese

Year completed: 2021

Area: 861 square feet (80 square meters)

Formative Coffee (pp. 60–63)

formative.coffee

Design: Projects Office (projectsoffice.co)

Photography: French + Tye

Year completed: 2019

Area: 861 square feet (80 square meters)

Grounds + RNCR Roastery (pp. 64–67)

rustynails.cz

Design: KOGAA Studio (kogaa.eu)

Photography: Alex Shoots Buildings

Year completed: 2020

Area: 1,292 square feet (120 square meters)

Hotel âme (pp. 68–73)

hotelame.com

Design: In-house

Photography: Manfung Cheung

Year completed: 2021

Industry Beans (pp. 196–201)

industrybeans.com

Design: March Studio (march.studio)

Photography: Peter Bennetts

Year completed: 2021

Area: 4,736 square feet (440 square meters)

Intelligentsia Coffee (pp. 154–159)

intelligentsia.com

Design: Standard Architecture (standardarchitecture.com)

Photography: Benny Chan/Fotoworks

Year completed: 2019

Area: 2,497 square feet (232 square meters)

Project Credits

Le Peloton Café (pp. 74–79)

lepelotoncafe.cc

Design: CUT architectures (cut-architectures.com)

Photography: David Foessel

Year completed: 2022

Area: 409 square feet (38 square meters)

Loquat Coffee (pp. 160–165)

loquatcoffee.com

Design: Joongho Choi Studio (joonghochoi.com)

Photography: B For Brand (bforbrand.co)

Year completed: 2022

Area: 1,055 square feet (98 square meters)

Milky's Coffee (pp.166–171)

milkys.ca

Design: Batay-Csorba Architects (batay-csorba.com)

Photography: Doublespace Photography

Year completed: 2019

Area: 301 square feet (28 square meters)

Monmouth Coffee (pp. 80–87)

monmouthcoffee.co.uk

Design: Sheppard Robson ID: SR (sheppardrobson.com)

Photography: Jack Hobhouse

Year completed: 2018

Area: 13,993 square feet (1,300 square meters)

Nagasawa Coffee (pp. 222–227)

nagasawacoffee.net

Design: ARII IRIE Architects (ariiirie.com)

Photography: Kai Nakamura

Year completed: 2018

Area: 1,055 square feet (98 square meters)

Nemesis Coffee (pp. 172–179)

nemesis.coffee

Design: Perkins&Will (perkinswill.com)

Photography: Ema Peter

Year completed: 2020

Area: 2,110 square feet (196 square meters)

Omotesando Koffee (pp. 88–93)

ooo-koffee.com

Design: Perinelli Design (perinellidesign.com)

Photography: Tony Murray

Year completed: 2018

Area: 592 square feet (55 square meters)

Original Coffee (pp. 94–97)

originalcoffee.dk

Design: Space Between (spacebetween.dk)

Photography: Armin Tehrani via Værnis Studio

Year completed: 2021

Area: 1,345 square feet (125 square meters)

PONT Coffee (pp. 228–233)

pontcoffee.com

Design: Studio stof (stof.kr)

Photography: Kim Donggyu

Year completed: 2022

Area: 2,562 square feet (238 square meters)

Roseline Coffee (pp. 180–183)

roselinecoffee.com

Design: In Situ Architecture (insituarchitecture.net)

Photography: In Situ Architecture

Year completed: 2019

Area: 1,023 square feet (95 square meters)

Sawerdō coffee + bakery (pp. 98–101)

sawerdo.ch

Design: BUREAU (bureau.ac)

Photography: Dylan Perrenoud

Year completed: 2021

Area: 2,153 square feet (200 square meters)

The Second Coffee Brewers (pp. 234–241)

Design: STUDiO DOHO (studiodoho.com)

Photography: Brian Chua

Year completed: 2019

Area: 1,076 square feet (100 square meters)

Single Estate Coffee Roasters (pp. 102–107)

singleestatecoffee.nl

Design: ninetynine (ninetynine.nl)

Photography: Ewout Huibers; Single Estate Coffee Roasters

Year completed: 2019

Area: 1,076 square feet (100 square meters)

SSAP Coffee (pp. 242–247)

Design: design by 83 (designby83.co.kr)

Photography: Kim Donggyu

Year completed: 2021

Area: 1,033 square feet (96 square meters)

Thor Espresso Bar (pp. 184–189)

thorespressobar.tumblr.com

Design: Phaedrus Studio (phaedrus.studio)

Photography: Ryan Fung

Year completed: 2019

Area: 700 square feet (65 square meters)

TYPIKA Coffee (pp. 108–113)

typika.coffee

Design: KOGAA Studio (kogaa.eu)

Photography: Alex Shoots Buildings

Year completed: 2019

Area: 1,292 square feet (120 square meters)

Upstanding Citizens (pp. 202–207)

upstandingcitizens.com.au

Design: We Are Humble (humble.website)

Photography: Peter Clarke

Year completed: 2019

Area: 753 square feet (70 square meters)

WAY Bakery (pp. 114–117)

waybakery.fi

Design: Studio Joanna Laajisto (joannalaajisto.com)

Photography: Mikko Ryhänen

Year completed: 2018

White Rabbit Surf Café (pp. 118–125)

Design: SOLOVEYDESIGN (soloveydesign.com.ua)

Photography: Yevhenii Avramenko

Year completed: 2021

Area: 700 square feet (65 square meters)

Acknowledgments

Café Cool: feel-good inspiring designs is the result of many talented professionals. The book would not have happened without their commitment, dedication, and passion.

Thank you to the following professionals at the publisher: Georgia (Gina) Tsarouhas (Project Coordinator and Senior Editor), Nicole Boehringer (Art Director), Ryan Marshall (Senior Graphic Designer), and Jeanette Wall (Editor).

Thank you to the cafés and coffee shops for sharing your stories and providing quality coffee in well-designed spaces.

Thank you to the architects and designers for your artistic and creative designs that make moments of time in cafés and coffee shops more enjoyable and meaningful.

Thank you to the photographers for your assistance and for your wonderful photos that so artistically capture the essence of the cafés and coffee shops.

Thank you to all farmer growers, roasters, and baristas as enjoying coffee in well-designed spaces would not be possible without your knowledge and hard work.

Thank you to the following people, at great risk of unintentionally overlooking someone, for their assistance—Mary Albi, Marick Baars, Anne-Laure Cavigneaux, Benjamin Clarens, Camille Comte, Peter Dye, Katerina Gkimizoudi, Shihhwa Hung, Katherin Iversen, Tina Kulic, Kim Lai, Yehia Madkour, Yann Martin, Sean Nam, Laurika Olayvar, Maud Petit, Chao Pon, Adam Rozakis, Amelia Starr, Carolina Stary, Ava Steer, Amy Woodroffe, and Jamie Yelo.

Finally, thank you to all readers of the book and everyone who enjoys coffee in spaces with feel-good inspiring designs!

Published in Australia in 2023 by
The Images Publishing Group Pty Ltd
ABN 89 059 734 431

Offices

Melbourne
Waterman Business Centre
Suite 64, Level 2 UL40
1341 Dandenong Road
Chadstone, VIC 3148
Australia
Tel: +61 3 8564 8122

New York
6 West 18th Street 4B
New York, NY 10011
United States
Tel: +1 212 645 1111

Shanghai
6F, Building C, 838 Guangji Road
Hongkou District, Shanghai
200434
China
Tel: +86 021 31260822

books@imagespublishing.com
www.imagespublishing.com

Copyright © The Images Publishing Group Pty Ltd 2023
The Images Publishing Group Reference Number: 1697

All photography is attributed in the Project Credits on pages 250–253, unless otherwise noted.
Page 2: Benny Chan/Fotoworks (Standard Architecture, Intelligentsia Coffee); page 4: Ema Peter (Perkins&Will, Nemesis Coffee); page 6: Yevhenii Avramenko (SOLOVEYDESIGN, White Rabbit Surf Café); page 8: James John Jetel (Range Design & Architecture, Dayglow Coffee); page 11: Ema Peter (Perkins&Will, Nemesis Coffee); page 12: David Foessel (CUT architectures, Coutume – Galeries Lafayette Haussmann); page 15: Oculis Project (Roar Studio, Drop Coffee); pages 16–17: LMNB Studio (Minnaërt Studio, Back In Black); page 248: Ryan Marshall (my thanks to the team at Industry Beans, Chadstone); page 255: Hey!Cheese (Phoebe Says Wow Architects, Fifteen Steps Workshop Coffee)

A catalogue record for this
book is available from the
National Library of Australia

NATIONAL LIBRARY OF AUSTRALIA

Title: Café Cool: feel-good inspiring designs
Author: Robert Schneider
ISBN: 9781864709681

This title was commissioned in IMAGES' Melbourne office and produced as follows:
Editorial coordination Jeanette Wall, *Graphic design* Ryan Marshall,
Art direction/production Nicole Boehringer, *Senior editorial* Georgia (Gina) Tsarouhas

MIX
Paper from
responsible sources
FSC® C019910

Printed on 140gsm Da Dong Woodfree paper (FSC®) in China by Artron Art Group

IMAGES has included on its website a page for special notices in relation to this and its other publications. Please visit www.imagespublishing.com

Every effort has been made to trace the original source of copyright material contained in this book. The publishers would be pleased to hear from copyright holders to rectify any errors or omissions.

The information and illustrations in this publication have been prepared and supplied by the author and the contributors. While all reasonable efforts have been made to ensure accuracy, the publishers do not, under any circumstances, accept responsibility for errors, omissions and representations, express or implied.